Portraits with an iPhone

Photo Techniques for Pro Quality Images

Jake Durham AMHERST MEDIA, INC. BUFFALO, NY

Published by:
Amherst Media, Inc.
PO BOX 538
Buffalo, NY 14213
www.AmherstMedia.com

Publisher: Craig Alesse
Associate Publisher: Katie Kiss
Senior Editor/Production Manager: Barbara A. Lynch-Johnt
Senior Contributing Editor: Michelle Perkins
Editor: Beth Alesse
Acquisitions Editor: Harvey Goldstein
Editorial Assistance from: Carey A. Miller, Roy Bakos, Jen Sexton-Riley, Rebecca Rudell
Business Manager: Sarah Loder
Marketing Associate: Tonya Flickinger

ISBN-13: 978-1-68203-453-8
Library of Congress Control Number: 2021930357
Printed in the United States of America
10 9 8 7 6 5 4 3 2 1

AUTHOR YOUR IPHONE BOOK WITH AMHERST MEDIA

Are you an accomplished iPhone photographer? Publish your print book with Amherst Media and share your images worldwide. Our experienced team makes it easy and rewarding for each book sold and at no cost to you. Email submissions: craigalesse@gmail.com.

 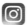

www.facebook.com/AmherstMediaInc
www.youtube.com/AmherstMedia
www.twitter.com/AmherstMedia
www.instagram.com/amherstmediaphotobooks

Contents

About the Author

An Oklahoma-based fine art photographer, Jake Durham has had photographic works featured by the Professional Photographers of America, *Oklahoma Today Magazine,* and other local publications. Originally from Chicago, Illinois, he spent most of his career as a pilot before going back to school to earn a doctorate in education. He now works as a university professor.

Jake is the father of two teenagers. He spends his free time teaching and sharing his passion for photography. Jake is studying to obtain a Certified Professional Photographer accreditation and is also working on additional educational photography books.

Jake's work and photography interests include:

- fine art photography
- cityscape & landscape photography
- urban exploration photography
- macro photography

Jake currently resides in Konawa, Oklahoma.

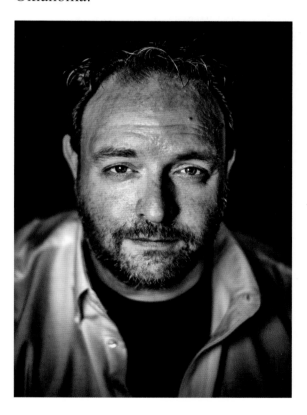

Introduction

I love looking at photographs. It matters little how good or a bad one is, and it amazes me to see the images people capture and say, "This is what I took because it meant something to me." I have loved taking photos ever since I was a kid, and I purchased my first DSLR (digital single-lens reflex) over ten years ago. In fact, a DSLR is all I ever shot with. However, I, like most people, neglected to consider the one item I carry in my pocket every day.

The iPhone has put a camera into the hands of millions, and people take more pictures now than ever. We flood social media with images and devour storage space on our phones, computers, and cloud-based services. At no other time in history have we had the ability to take a photo and make it immediately accessible to millions around the globe. Society has become obsessed with taking pictures.

People often tell me they wish they could afford a DSLR like the one I

"Images of people are a record of our lives."

shoot with, and that they want their photos to look like mine, but the reality is that your iPhone is a powerful tool that has the capability of taking stunning images. We have been conditioned to think that only quality images can come from high-end Nikons, Canons, and Sonys. That iPhone in your pocket is expensive and, in some cases, costs more than an entry-level DSLR. Yet, it is convenient and almost always at hand.

People are one of the most common subjects we capture. While at times, images of people appear to be random, they are, in fact, so much more. They convey who we are as people. These images can evoke emotion, convey humanity, show a sense of humility, remind us of our frailty, and portray the beauty and art in human form. Images of people are a record of our lives.

An important concept in photography is understanding how to make the subject interesting. This is easier said than done. Why? Because we all view the world around us very differently. While this concept is true regardless of

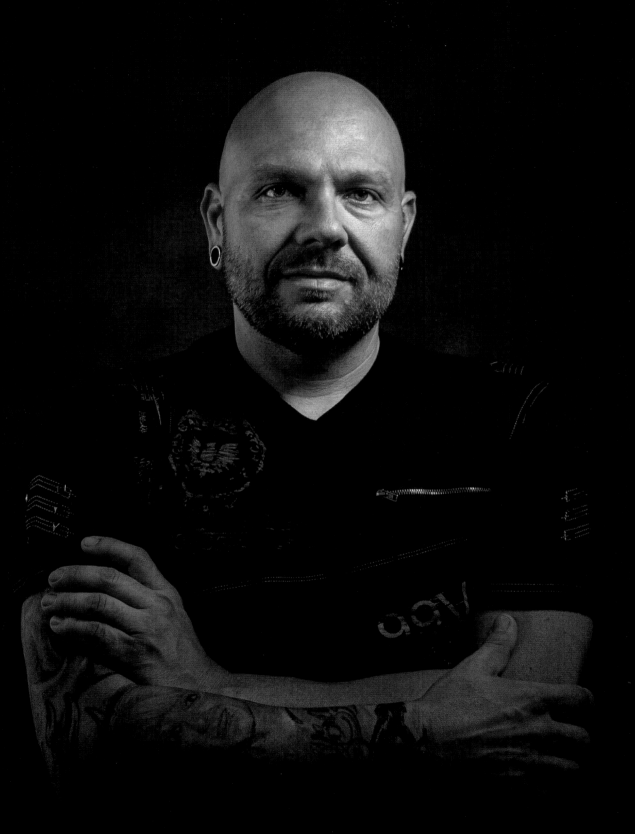

the nature of the subject, it is especially important to keep in mind when photographing people. To make photographs of people interesting, we need to understand how to capture their essence, and at times, capture a side of them that maybe only we see. One needs to know why we are taking the photo. One also needs to understand the scene and how to make it complement the subject. There is no one perfect photo for any given person, nor for every situation.

There is an array of styles to choose from when photographing people. A snapshot is ideal for capturing that spur-of-the-moment event. Portraits capture people in junctures, poses, and settings that are intended to render their likeness, mood, and personality. Headshots are similar to portraits, but they are used to convey a more specific message. Environmental photography can be any combination that captures people in a natural setting, such as work or at events. Each of these styles can be artistic.

The Internet bombards us with an oversaturation of information that often confuses and supplies us with more

"There is no one perfect photo for any given person, nor for every situation."

than we can retain. There is no shortage of people telling us, "My way is better," and we become sold on that idea. However, I have learned over the years of being a photographer that the principles that work best are in keeping with what is practical and straightforward. The basics always work.

Please join me as I share practical applications, techniques, and tools I use in iPhone photography, including:

- Why you should use your iPhone for photography
- Learning to work within the iPhone's capabilities and the importance of knowing equipment limitations
- JPEG, HEIF, TIFF, and RAW: What's the difference?
- Camera apps
- Using Creative Cloud and getting your pictures to the computer
- Composition and basic principles of photography
- The art of the snapshot
- The art of portraiture
- Taking images that suit your subject's style and introducing people to a new way of viewing themselves
- Editing with mobile applications such as Lightroom Mobile Photo Editor
- The dreaded selfie
- Optional lighting techniques and equipment

- Interchangeable lenses
- Finding your unique style

As you read, I want you to take the time to look at each of the photos. I mean really look at them. Pay attention to things like how I framed each subject, where the focus was, if there were any distractions, and how the light was distributed throughout the scene. Also, notice that these are not professional models. They are friends and family. I will also share with you the mistakes I have made over the years, while emphasizing that taking a bad photo isn't a bad thing. I want you to fall in love with photography.

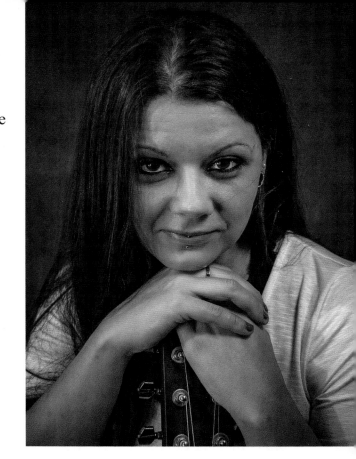

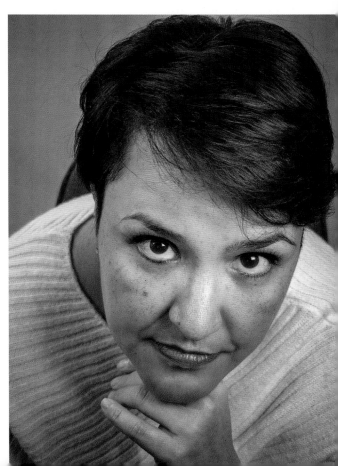

1. Get Close!

"If your pictures aren't good enough, you're not close enough."

—Robert Capa

Robert Capa had it right. I am a close-up photographer—well, at least when it comes to portraits. We make new discoveries when we see the world this way. This is one reason why macro photography—you know, that really up-close and magnified stuff—is so fascinating (image 1.1). We see things in a way we are not generally used to seeing them. Color and details pop. Textures can become so enhanced you almost feel them. Of course, there's nothing wrong with seeing the bigger picture, but that doesn't always work for portraits, and it certainly does not work for headshots.

When we take photos from a distance, there is a potential for distractions. While additional objects in a scene are sometimes desirable, they can detract from what we really want to see. We have all done it: taken that one photo that doesn't look quite right. You know the one I'm talking about. In fact, I bet if you look through your phone, you will find a plethora of them.

This is a great time to start flipping through your images and identify the ones you are not happy with. Don't forget to recognize the good ones, too. Ask yourself why one was better than the other, and what can be improved. As we cover topics, take an opportunity to go back and ask yourself how you could apply these techniques to those photos.

A common problem I see when people take pictures, regardless of the type of camera used, is that they accept the outcome of their images. There is very little thought regarding composition, exposure, focus, and other considerations. Some people are satisfied with their pictures, which is great! Others wonder why my images or their friend's images look professional. The reality is

"While additional objects in a scene are sometimes desirable, they can detract from what we really want to see."

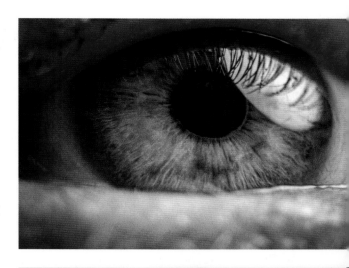

that you don't need to be a professional photographer to take stunning photos.

When it comes to creating images of people, it is essential to ask yourself why you are capturing an image of that person. Is it for fun? Is it to take a quick snapshot, or are you striving for something a bit nicer? Is the image to be made a casual photo of a family member or friend, or will it be made with professional intent and creative vision?

Remember to get close for improved portraits. Have you ever taken an image of someone and wondered why the subject looks like an ant? Or why the surrounding elements are more prominent than your subject? Someone once told me I have the advantage of zooming with my professional camera, and they can't do that with their iPhone. But you can, and the zoom feature is you. Don't be afraid to get close to your subject to take their picture (see image 1.2). Flip through magazines and think about all of the images you see of people. How often is the camera very far away from someone?

2. iPhone Portraits

Why use your iPhone to take portraits? Well, why not? I make it sound easier than it is really. The reason I say that is because using your iPhone as a camera takes some practice, as well as mental conditioning. As a DSLR (digital single-lens reflex) camera user, I struggled with grabbing my phone. I would be out and about, see something, and say, "Of course! I don't have my camera with me today." However, that is not the case. The first step in taking better photos with your iPhone is not to think about it as a phone. An iPhone is an expensive tool, but we seldom treat it like one.

We can relate to casually removing our phone from our pocket, tossing it somewhere after coming home, getting in the car, or arriving at work. An entry-level DSLR from Nikon or Canon costs around $400 U.S. Would you treat it that way? I imagine not. Yet this is how we treat our iPhones. Remember that your phone costs just much, and likely more, than an entry-level DSLR. In many cases, the camera that comes with your iPhone can produce the same

or better image quality than an entry-level DSLR.

While the iPhone has limitations, it can capture stunning, professional-looking photos—the kind of photos people drool and pine over. The same ones that leave friend and clients speechless when I say, "Yep, that was shot on an iPhone." Some jokingly say that it's bad enough I can take stunning images as is, but then to show off something so striking from a phone is almost nauseating. The techniques I use are not special, and these are skills that anyone can learn.

An iPhone is an excellent tool because that camera we often neglect to remember is right there with us most of the time. It is something most of us use daily, and with just a little practice and patience, anyone can learn to take professional-looking images with their iPhone, regardless of the subject matter. Plus, your iPhone has some traits that a DSLR doesn't. For example, it can pass through customs with little scrutiny, and it can remain safely by your side as you travel. iPhones also have some

level of water resistance. That DSLR? Well, not so much.

Limitations

As good as your iPhone can be at producing quality photos, it has some limitations you should be aware of. However, limitations are not a bad thing, and it is important to understand what you are working with. I learned long ago that it is the photographer that makes a great image, and you don't need fancy equipment to do it.

I can take a photo of any subject on any camera. However, there are a few caveats to this statement. One, I need to understand some basic photographic concepts. Two, I need to know what I can do. Three, I need to understand my camera's limitations and have an in-depth understanding of how it works. Once I am proficient in these areas, capturing the image is a snap—literally.

There are limitations to using an iPhone for photography, just as there are with the most advanced DSLRs. One thing to be aware of is optical quality. Camera lenses are made from an array of quality components. High-end lenses are constructed from some of the finest materials, and many optical impurities are removed during the manufacturing process. Expensive coatings are applied to minimize glare, and

"I learned long ago that it is the photographer that makes a great image, and you don't need fancy equipment to do it."

modern lenses incorporate sophisticated electronics ranging from autofocus motors to image-stabilization systems. The optical glass on your iPhone is not as high quality, so you can expect some imperfections in color and, at times, sharpness.

While iPhones can zoom, the feature is applied digitally versus optically. Digitally zooming applies a crop to the image to increase the size. This decreases quality. The best way to zoom with an iPhone is the old-fashioned way. You have to get closer.

Battery life can be significantly reduced when using an iPhone for photography. Professional photographers understand the importance of adequate power supplies, whether in the form of spare batteries or a long enough cord. However, your iPhone is not dedicated to functioning as a camera. Therefore, the multiple applications running in the background drain the battery. iPhones also use their screen for viewing and capturing images, as there is no dedicated viewfinder. This drains the battery

even faster. The number of photos one can take is dependent on the iPhone model and battery age. Therefore, careful consideration needs to be made regarding power sources when shooting with your phone.

Image sensors used in camera phones are small—much smaller than their DLSR counterparts. Therefore, they are limited in the amount of information that can be processed. While a camera phone may have a megapixel rating similar to one of its DSLR big brothers, it does not mean that you will achieve an identical image. There are limitations regarding how big the final photo

can be, how many colors the sensor can produce, and the quality of the final image. After all, the image sensor in your iPhone is about the size of the fingernail on your pinky finger. The image sensor in a full-frame DSLR is 35mm. That's a significant difference in the amount of data that can be recorded.

3. The Basics

"I'm not a technical photographer, and I try to keep things as simple as possible."
—Annie Leibovitz

No matter the type of camera you are using (e.g., DSLR, smartphone, point-and-shoot), you have to understand the basics if you want to take good photos. You need to have some understanding of how your device works. Sure, you will eventually find what you are looking for if you muddle around in the dark long enough, but that doesn't help you understand why an image was bad, why one was good, and how to get the shot you were really after. Even professional photographers miss shots because they are using equipment they are not familiar with. Sometimes, they even screw up when they know what they are doing.

Annie Leibovitz makes a powerful statement that I remind my students of. You do not need to be a technical photographer to be a great photographer. But what is a technical photographer? Over the years, I have noticed that photographers tend to fall into one of two categories. One is very technical and scientific. There may be very little artistic interpretation, and everything from the camera, to lighting, to external apps, must be perfect. This type theorizes that the best images are captured via science and precise mathematical calculations. A practical photographer, on the other hand, relies on a thorough understanding of the basics. They don't need to understand the physics behind light and all the properties at work by the time it reaches the image sensor. Nor do they chase the latest gadget. Photography is an art form.

Regardless of what type you identify with, you need to understand some basic principles. For example, while cameras are scientifically complex, the process of how an image gets from imagination to reality is not complicated. Light from your subject and the surrounding area passes through a series of lenses where it is refracted (bent) until it reaches a point where the light converges. From there, the light continues to travel to a point where it is projected on a capturing device. On digital

cameras, this is called an image sensor. Easy, right? And not super technical. To take good photos, you will need to learn some standard terms.

The Image Sensor

In the pre-digital era, images were recorded on film. In digital cameras, images are recorded on an image sensor. Image sensors are rated by their sizes. Consumer sizes range from $^1/_{2.55}$ inch (iPhones) to 35x24mm (a full-frame DSLR). Image sensors are also rated in megapixels (MP), which is a representation of how much detail can be recorded on a given sensor. For example, the iPhone XS's primary image sensor is rated at 12MP.

Receptors on an image sensor record shades of light and color. This information is then converted into digital bits of information. From there, an internal computer processes this information to create the final image we see. This is the dark, soul-capturing wizardry that resides inside cameras.

Focal Length

Focal length is a term that relates to camera lenses. The focal length is the distance expressed in millimeters (mm) from a point within the lens where light converges. This is a hypothetical point and is also referred to as the optical center of a lens. From this point, the light continues to travel inside the lens until it is projected on the image sensor. The distance between this convergence point and the image sensor is the focal length. The smaller the focal length number, the wider the field of view, or the more we can see in a scene. The larger the number, the smaller the field of view, or the less that is seen. The focal length of the built-in lens on the iPhone XS is approximately 4mm.

ISO

Typically, ISO refers to the International Organization for Standardization. In camera language, it refers to how sensitive an image sensor is to light. ISO is represented by a numerical scale. The lower the number, the less sensitive the image sensor is to light (darker images). The higher the number, the more sensitive the image sensor is (lighter images). For example, the iPhone XS has an ISO range from 25 to 2,500.

ISO settings have limitations to be aware of—primarily, the introduction of noise. Some cameras are much better at minimizing noise (akin to grain in film), and many editing programs offer some

noise-reduction tools. However, be aware that lower ISO numbers will yield the clearest image, while higher ISOs produce noisier images. Depending on the look you are trying to achieve, more noise may be desirable.

The Shutter

Usually, when people think of the shutter, they are referring to the button one presses to take a photo (a shutter button). However, the shutter is actually the device in the camera that controls how long the image sensor is exposed to light (the shutter speed). These devices are an internal component of the camera and can be mechanical or digital.

Shutters speeds are represented by a unit of time and expressed as a fraction of a second to whole seconds. The larger the number, the longer the shutter is open, and

top. **Noise caused by high ISO.**

bottom. **In this example, the shutter speed was set to ¹/₅₀ second. The light and chain in the middle ground are relatively clear due to their motion in relation to the shutter speed. The chain in the foreground, and the fan blades in the background, are blurry. Their motion relative to the shutter speed was too fast, resulting in motion blur.**

the smaller the fraction, the shorter the duration. The iPhone XS, for example, has a shutter speed duration from $^1/_2$ to $^1/_{12,000}$ second. At $^1/_2$ second, the image sensor is exposed to light for an extended period, resulting in brighter photos. At $^1/_{12,000}$ second, the image sensor is exposed to light for a shorter duration, resulting in darker photos.

Shutter speeds also affect how motion is captured. We can freeze time or make things blurry. The longer a shutter is open, the more blur will be present in an image for a given situation. Fast shutter speeds freeze motion. Picture an image of a wispy waterfall. That dreamy appearance is the result of a slower shutter speed. Slow shutter speeds are a necessity for capturing images of the Milky Way. Fast shutter speeds are ideal when photographing sports and other fast-moving subjects.

Aperture

The lens aperture has several purposes and serves the same function as the iris of your eye. The larger the opening, the more light enters the camera. A smaller opening allows in less light. This opening is expressed by a numerical value referred to as an f-stop. F-stops get a little confusing due to the way they are numbered. A smaller number, such as an f/1.8, means that the aperture is open very wide, which results in more light entering the camera and brighter photos. A larger f-stop number, such as f/22, represents a very small opening, which allows in less light and yields darker photos.

Aperture also affects how much of a scene is in focus. Wider apertures result in blurred fore- and backgrounds, and fewer elements in the scene are in focus. Smaller apertures bring more of the scene into focus. You may often see

left. In this example, attaching a telephoto lens to the camera and moving close to the subject resulted in a shallow depth of field. The flower is in focus, while the background is blurred. This helps to draw attention to the subject.

above. Moving farther away from the subject and using a wide-angle lens (or the stock camera lens) produces a larger depth of field. This is beneficial for landscape photography, where the photographer often wants viewers to see as much detail as possible. In this instance, the entire scene is in focus from corner to corner.

a smartphone manufacturer convey the lowest aperture available on a given model. However, unlike their DSL counterparts, smartphones offer little control over this feature, and it is often manipulated through software applications. The iPhone XS, for example, has a feature called Portrait mode, which is found in its native camera app. With this feature, software digitally blurs everything outside of the central focal point to simulate a change in aperture.

Depth of Field

Depth of field refers to the amount of the scene that is in focus. This is often expressed in inches, feet, and infinity. It can also be expressed in millimeters (mm) or meters (m). Several factors affect the depth of field. Larger apertures

"Depth of field is regularly used to our advantage when taking portraits."

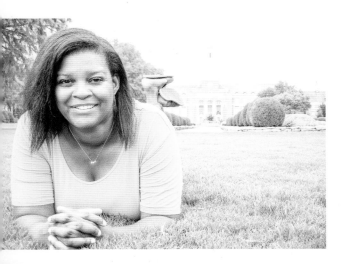

A shallow depth of field blurs the world around the subject and helps to draw attention to what we want to focus on. One disadvantage to using an iPhone for photography is that the depth of field is often large. This can leave objects in focus that may not be desirable. For instance, when using backdrop for portraits, a larger depth of field can make it easy to see imperfections in the material, such as wrinkles. This might necessitate editing to remove the flaws. Some camera software applications use AI (artificial intelligence) to synthetically blur the background and simulate a change in depth of field.

Depth of the field is also directly related to the focal length of a lens and the camera-to-subject distance. Longer focal lengths or being closer to the subject result in shallower depths of field. Shorter focal lengths or more distance from the subject result in a larger depth of field. Changing focal length or distance from a subject are the best solutions for controlling depth of field in iPhone photography.

(smaller numbers) change the depth of field and make it narrow (often referred to as shallow), while smaller apertures (larger numbers) increase the depth of field and bring more of the scene in focus. Depth of field is regularly used to our advantage when taking portraits.

"Exposure is the balance between the brightest and darkest elements in a photo."

Exposure

Exposure is the balance between the brightest and darkest elements in a

photo. An image that is appropriately exposed is not too bright or too dark. Exposure is controlled by adjusting the shutter speed, ISO, and aperture (if applicable). Exposure can also be influenced by the amount of available or introduced light.

Composition

Composition refers to the arrangement of your subject and all the other elements in the frame. Overall, the best compositional technique is to apply the Rule of Thirds. To do this, determine how to activate the gridlines feature on your phone's screen. When applying the Rule of Thirds, your subject should be offset and underneath one of the horizontal or vertical gridlines.

Using the Rule of Thirds is appealing to the eye. It also forces you to think about what is taking place around your subject. While this is a widely accepted industry practice, there are occasions when the rule may not be ideal.

I apply the Rule of Thirds regardless of the subject. Even with close-up portraits, you can identify which parts of my subject are concentrated within a third of the frame. There are some instances, however, when the subject appears to fill the entire frame evenly.

The focal point, or where the focus is concentrated, is just as important as subject placement for a given scene. I always ensure that my focal point is on the subject's eyes. If you only focus on one trait when taking portraits, make sure it is the eyes. This is what people are immediately drawn to when they first see an image. I will also set a focus point on the eye that is closest to me.

Formats

JPEG. Images are often captured in JPEG (Joint Photographic Experts Group), a file format that has been around since 1992. This format can display over 16 million colors, takes up little storage space, and is ideal for web viewing. JPEG is also the standard format for native camera apps. While the JPEG format will most likely be around a while longer, it has some limitations in quality and editability.

JPEG images are compressed for efficient use of storage space. Because of this, some information contained within that image is destroyed. Are you old enough to ever have dubbed a cassette tape? If so, you might remember that the copy was always slightly lower in quality than the original. If you made a copy of the copy, it got even fuzzier. JPEGs work similarly. The image is initially compressed once it is created. If you upload that image to social media, it is compressed again. What if

above. **Gridlines.**

you decide to save that image back to your phone from social media? Yep, it is compressed again. Each subsequent compression results in a loss of quality, and it starts to become obvious.

When editing your photos, think of the JPEG format like baking a cake. When it is processed, it's baked. If it isn't cooked enough, you can put it back in the oven a bit longer. However, what happens if you burn the cake? When we allow the camera software to process an image, it determines the best values for sharpness, color, exposure, contrast, and an array of other adjustments. Therefore, think of taking pictures in a JPEG format like trying to fix an already cooked, or worse, a burned cake. You can always put it back in and make some minor adjustments, but there is no way to reverse any damage.

HEIF. High Efficiency Image Format (HEIF) is the new kid on the block. It could one day replace the JPEG format. So, what is it? Well, HEIF offers many of the benefits of JPEG, and then some. HEIF files use a lossless compression format. In other words, where information is lost when a JPEG is created, HEIF files maintain their integrity. Like JPEGs, they require little storage space, but HEIFs offer far greater color depth.

The downside is that not many applications can run HEIF files (sometimes seen as a .heic extension). Apple devices have the capability, and some Windows-based devices can display HEIF images. However, you may be required to download an additional program to open the file. Some social media outlets appear to accept HEIF files, but they are often converted to JPEG when uploading.

TIFF. TIFF (Tagged Image File Format) is a lossless compression file format. It yields the greatest resolution while maintaining image detail and image integrity compared to other

processed formats. These file sizes are quite large, and images can be layered or stacked together. Layering allows for the creation of images that contain a greater depth of color and multiple layers of editing adjustments.

Many printing and publishing companies use either TIFF or JPEG formats for the final product. In terms of size comparison, a processed high-quality JPEG image can yield a 9MB to 30MB file, whereas the same uncompressed TIFF image can be two or three times that size. While TIFF files are great for maintaining image quality, they also suffer from the same editing woes as a JPEG. TIFFs are better suited for converting and saving the final image after editing.

RAW. The RAW format is the best option for taking photos. RAW simply means unprocessed; it is not an acronym. RAW files are not image files, but data files. This means that there is no image recorded in the file because it has not been processed. A RAW file gives you the greatest flexibility in editing your photos and ensuring that you capture the highest-quality image. I only shoot in RAW, and until recently, it was almost impossible to take photos in RAW on a smartphone. Your iPhone has the capability of displaying and reading a RAW data file. However, it

temporarily processes the information to create a viewable image that you can work with.

RAW is a generic term, and manufacturers often have their own file extension names. For example, Nikon is .NEF, Canon is .CRW, and Sony is .ARW. While the file extensions are not universal among manufactures, the concept is the same: a digital, uncompressed, and unprocessed file with no correction of any type applied. Once the image is processed, it will be saved with a file extension, such as .jpg or .tif.

You will notice stark differences if you view a RAW file next to a processed image taken with your stock camera app. Often a RAW image is drab, appears to lack color, and sometimes they are effectively referred to as being black & white in appearance. This is because no image processing has taken place. Your iPhone's camera takes images in a RAW format, but its software applies color, hue, saturation, contrast, and lighting adjustments based on what it calculates will produce an ideal image. In short, your iPhone effectively "Photoshops" your image without you knowing it.

"The RAW format is the best option for taking photos."

A universal RAW file extension format is DNG (Digital Negative), which works well with iPhones. It is the key to tapping into your iPhone's capabilities of being a high-quality camera.

Shooting in a RAW format also offers the greatest advantage when it comes to editing. Remember the JPEG and baking a cake analogy? Because RAW is like an unbaked cake, the possibilities are almost endless. You can cook it just right, or really burn it. However, with RAW, you can undo it and start over! RAW formats allow the greatest flexibility when it comes to editing, being creative, and making your photos look like your vision.

HDR. HDR (High Dynamic Range) format is not new, but it is offered in many phone apps as a high-quality image option. The purpose of capturing HDR images is to produce photos with a range of contrast (light and dark) closer to the one the human eye can perceive. A camera can capture five to seven stops of light for a given image, while the human eye can detect as many as twenty. Think of a stop of light as a change in shading.

Imagine a color chart with pure white on one end and absolute black on the other. Computer screens can display up to 256 different shades of gray between white and black, while the human eye can distinguish over 500. Now, pick a point on either scale and count five to seven spaces away in either direction. That is the range your camera can effectively capture light. Now do the same thing, but count twenty spaces to see the difference in how our eyes capture light. Creating an HDR photo is a process of combining different images of varying contrast and exposure values to increase the dynamic range of the final image. The iPhone XS takes three pictures and combines them automatically. This is often two JPEGs and one RAW image. Some apps take and combine up to five images. Each manufacturer determines the final output file extension; however, it is often .jpg, .hdr, or .tif. This is important to know because it can directly affect your ability to edit the image after it is processed.

You can create an HDR image on your own by using a technique called bracketing. To do so, capture as many photos as you like, keeping the camera stationary, and change only the exposure. Then use a program like Lightroom or Photoshop to combine and align the images into a final HDR product.

HDR capture is best suited for landscape photography and has no real application in portraits, although people do sometimes use the format. HDR

processing can make an image appear less than realistic and almost cartoonish when applied to a scene that does not call for its use.

Make Sure It's Archival. In today's digital age, many photos never make their way off of the smartphone or computer. The downside to technology is that it changes. Inevitably, a new format will come along and take the place of an older one. The JPEG format has been around for thirty years, but how much longer will it last? When digital cameras were first introduced, the VGA format was all the rage; however, no one uses the format any longer. Also, there is no way of knowing when computer manufacturers will cease supporting a given format. Remember the floppy disk?

An archival format will stand the test of time. It will still yield the same results, or close to it, as it did when it was new. Film is an excellent example of an archival format. If it is properly stored and cared for, it will last. More importantly, there is no special program required to view what is on it.

Digital formats will eventually fade. What happens to all the images you have taken over the years once the format is no longer supported? You may no longer be able to access the files you once cherished. The challenge with

"If your photos are important to you, take the time to print them. Create an archive."

digital images is not only in the ability to store them, but to convert them to the latest format when possible. If your photos are important to you, take the time to print them, and make them future-proof.

4. About Light

Quality light, whether it comes from the sun or an artificial source, is your ally in achieving great images. The better the quality, the more the fine details will stand out in your photographs. Quality light produces more vibrant colors and enhances the sharpness of your images.

Light can serve the purpose of illuminating your subject or the entire scene. While today's cameras are good at taking pictures in low-light settings, the technological advances will never make up for a lack of ample, quality light.

Do you need to have an in-depth understanding of light? While it is undoubtedly helpful, the answer is no. But understanding some basics, such as why light is important or how it can be manipulated and controlled, is key

"Great light, whether it comes from the sun or an artificial source, is your greatest ally in achieving great images."

to creatingquality images. While the information contained in this chapter does not offer a comprehensive look behind the science of light, it will provide some useful information for you to consider as you practice photography.

There are several sources of light, in conjunction with lighting styles, and you will notice that I use several combinations of these types in my photography. I work with the lighting styles that are appealing to me, even though there are far more options to choose from. Often, I use a single light source, but I will use two or three lights on occasion. Though you don't need to purchase expensive equipment to take great photos, it is important to understand the limitations and challenges associated with different types of lighting.

Ambient Light

Ambient light is the most common form of light. When you think of ambient lighting, think of available light—that which is readily present for a given scene, and not light you have introduced. Light sources can be indoors or

outdoors. The most readily available source of ambient light is natural light.

Natural Light

The sun, as a light source, can yield incredible photographs. However, sunlight is never consistent and changes throughout the day. The sun provides a dynamic range of lighting options from the early morning hours, to harsh mid-day light, and to the fading glimmer of the last light of the day.

One should consider a few things when using natural light. The sun yields its most ideal shooting conditions during the golden hour, or periods of overcast conditions. Golden hour is one of my personal preferences, as is with many photographers. It is that period approximately sixty minutes after sunrise and sixty minutes before sunset when the sun yields some of its softest light. Colors and hues are rich reds, oranges, pinks, yellows, and yes, gold. It is the ideal time to take portraits, as well as an array of other photos.

Overcast skies act as a natural diffuser of light and often yield soft, well-balanced light with minimal shadows. Any shadows that are present are usually soft.

A less utilized shooting time is blue hour. This is a period just before sunrise or just after sunset when the sun is just below the horizon. Blue hour light is not ideal for portraits, but the skies are often a deep rich blue and can add a little flair to any scene.

Artificial Light

Indoor or artificial lighting can be another great option for portraits. These light sources can take many forms, ranging from halogen bulbs, to LEDs, to fluorescents, to tungsten or incandescent lighting. Even additional sources such as fire, candlelight, or outdoor lighting can be excellent options. Each light source has its limitations in terms of the quality of light it offers and how it affects the color in the final image. Each also has pros and cons regarding the type of shadows it can yield.

Keep it Soft

We have all seen it: that one image in which the highlights are blown out. Everything is bright white. The details are lost. Shadows have distinct, hard lines. Ideally, we want the light to be soft. Soft light yields softer images, and softer images are pleasing to the eye. The color looks great, and the details are stunning. Shadows evenly transition from one area of the subject to the next. There are many ways to soften the light, and you will need to experiment with different techniques to get the light

"One thing to remember is that harsh light comes from small light sources."

how you like it. It is equally important to consider how light affects your image as it is to ensure you are correctly framing your subject and inspecting for distractions.

As mentioned, clouds naturally diffuse sunlight. However, cloud cover is out of our control. With the sun, you get what you get unless you bring a diffuser on location. Indoor and outdoor lighting also tend to yield problems. It is more likely that there will be too little light than too much. However, we can control it by changing the brightness, if able, or covering the light source to diffuse it. We can also diffuse harsh light by learning to work in shade and with shadows.

One thing to remember is that harsh light comes from small light sources. Harsh light is also produced as the source moves farther away from your subject. Both of these conditions assume the light is not being diffused. This is why flash often yields an unflattering photo, and why the sun produces harsh shadows at midday. However, the larger the light source, and the closer it is to the subject, the softer it gets. Light

that is farther away is concentrated and less scattered than light that is close. Harsh light creates hard shadows and, often, defined lines on your subject. If the harsh light source is the sun, then it may cause the subject to squint. It can also wash out color.

Found and Reflected Light

Found light can be light that we introduce or that which is available from unintended sources. For example, light from a flashlight, street lamp, light from a building, or even a car's headlights are sources of found light. We can also illuminate our subject by reflecting light using a white piece of cardboard or poster board, standing in light reflected from a building, using light reflected from the subject's clothing, or bring another device to act as a reflector. Reflected light is often soft and is only a fraction of the available light. Reflected light may also be diffused light. Reflected light is often used to fill the shadows on a subject, but it can also be used to create more defined shadows.

Constant Lighting

As the name implies, constant light is constant. It is always on. This can be found in ambient lighting or it can be a light source that you introduce. There

are numerous constant light and diffuser kits you can purchase that provide a reliable light source and allow you the ability to control the light output, diffusion, and distance to your subject. Constant light has the advantage of providing instant results that you can see. In other words, you know what you are getting.

Speedlights (Flashes) and Strobes

These devices are often an enigma to beginning photographers and something they tend to stray from. However, these are sources of light I use almost exclusively, regardless of whether a shoot takes place indoors or outdoors. Speedlights are portable, and strobes may also be portable. Either one can be controlled. I can also use a combination of speedlights or strobes to achieve a desired lighting effect. I often use various softboxes and light modification devices to help control, diffuse, and shape the light.

I often use the Profoto and TricCam apps in conjunction with my lighting for iPhone photography. These are detailed in later chapters.

Key, Front, Back, Fill, Side & Accent Lighting

Wow! So many terms, but they are not hard to understand. I also reference these terms as I describe a setup for a shoot.

Key Lighting. Key lighting is your main light. It is the light used as the primary source to illuminate your subject. There are several locations to place key lighting. However, the ideal location is at a 45-degree angle to your subject and slightly above their eye level.

Front Lighting. Front lighting could be your key light, but it does not have

below. **A softbox can be used to diffuse hard light, making it softer.**

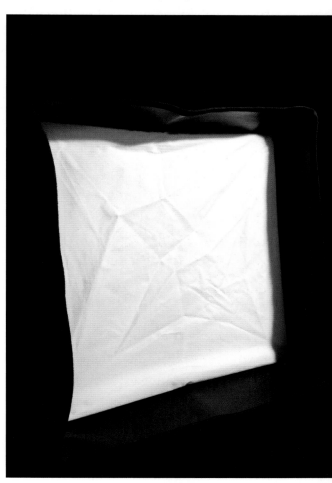

"Fill light can be placed in almost any location, depending on what you are trying to brighten."

to be. However, it is light that is in front of your subject. Front light is often undesirable and may cause your subject to appear two-dimensional. If front light is the sun, it can be harsh, cast shadows, or cause your subject to squint.

Back Lighting. Think of background lighting when thinking of backlight. The purpose of backlighting is to separate the subject from the background. Backlight can be used to illuminate the subject, create a silhouette, and light a backdrop. A backlight can also be your key light.

Side Lighting. Light that is perpendicular and 90 degrees to either side of your subject is side lighting. The key light may be a side light. Side lighting can also provide fill light. Side light can be manipulated to yield a unique, unconventional look.

Fill Lighting. Fill light is used to fill in the shadows of your subject. As a rule of thumb, fill light is approximately $\frac{1}{3}$ of the available light from the key light source, but it can be a 1:1 ratio. There is no right or wrong ratio of fill light to key light; it all depends on the specific look you are going for.

Fill light can be placed in any number of positions; however, it is often placed opposite the key light. For example, if a key light is set at 45 degrees to the left and slightly above the subject's eye level, the fill light will be placed to the subject's right at a 45-degree angle and at the same height and distance from the individual.

Fill light can be placed in almost any location, depending on what you are trying to brighten. For example, your key light could be at a 45-degree angle to your subject, with the fill light at a 90-degree angle to your subject on the opposite side. Fill light could be placed slightly behind the subject, or even below.

Some photographers use a reflector to create fill light.

Accent Lighting. An accent light subtly illuminates a specific area of the subject. There are many accent lighting sources. One of the most common types of accent lighting is a hair light—a light placed slightly above the subject's head at one of many angles. It could be above and at a 45-degree angle to the subject's head, behind and below the person and aimed upward, or any other combination. Sometimes accent lighting is referred to as kicker lighting.

Lighting Styles

While there are more lighting styles than those listed here, I have included samples of the types I favor. I use a given style for the desired look I want to achieve. Each of the following images were created with a Profoto C1, which resulted in exaggerated and defined shadows for emphasis.

Rembrandt. Rembrandt lighting is by far the most popular lighting style for portraits, due to its dramatic flair and use of shadows. This is one of my preferred lighting styles. Rembrandt lighting is characterized by a triangle-shaped patch of light on the subject's cheek opposite the light source. It is created by placing a key light at a 45-degree angle to the subject, and slightly above their eye level. Subtly moving the light higher, lower, fore, or aft will open or close the shadow between the nose and cheek. Experiment until you find the look that suits you.

In the first photo example, the subject is illuminated with Rembrandt lighting coming from their left. In the second example of Rembrandt lighting, a fill light was placed to the subject's right.

Butterfly. Butterfly lighting creates illumination that is almost even across the subject. It is created by placing the key light source directly in front of the subject and above their eye level. If done correctly, the subject's nose will cast a small shadow that resembles a butterfly on their upper lip. Fill light can be added to soften the effect.

Loop. Loop lighting is my favorite option next to Rembrandt lighting. The setup is almost identical. However, the light is moved slightly to open the triangular patch on the subject's cheek. A small loop-shaped shadow is formed from the subject's nose that points toward the corner of the subject's mouth. There is still a noticeable shadow on the cheek. Moving the light source slightly higher than Rembrandt lighting and somewhat more than 45 degrees will generally yield the desired effect.

Split. Split lighting is created by placing the key light approximately 90 degrees to either side of the subject. The shadow's strength and contrast are directly related to the angle, height, and distance of the light from the subject.

Open the Shadows

Don't leave people in the dark! While harsh light is undesirable, it is just as unflattering to place people in the shadows. This could result when photographing someone under a tree, or on the shaded side of a building, or from turning them to where a bright light source is to their side or back. In each instance, unwanted shadows darken

facial features, drown out the color, and hide details.

When we introduce light back into the scene, we "open" the shadows. This is often accomplished with one of the many sources of light previously described. However, some of the most common ways to add light are via a reflector, speedlight, or strobe. If you attempt to take a photo of a subject with a bright light source behind them, such as the sun, then a reflector may not do the job. I shoot into the sun often, and I love the effect it adds to a given scene. A speedlight and a softbox are my go-to choices for lighting a subject in this situation.

White Balance

Light sources are associated with a color temperature rating based on the Kelvin scale. In photography, this scale ranges from 2000K to 9000K. An image's color is warmer when the Kelvin temperature is lower, and colder when it is higher. Candlelight, for example, has a Kelvin rating of approximately 2000K. Strobes, speedlights, and the mid-day sun are approximately 5500K. Shade is roughly 7500K. Lower temperatures produce shades of red and yellow, mid-range temperatures are closer to white, and higher temperatures yield more blue.

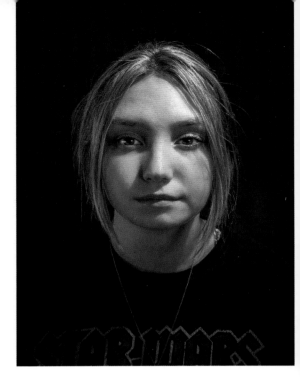

above. **Rembrandt lighting.**

If you are not shooting in RAW, then the default camera app will adjust the white balance to the most appropriate level for a given scene. If it's wrong, the image will not look right, and it can be hard to adjust in post-processing. You can make white balance corrections more easily during editing if you are shooting in RAW, and the wrong white balance was selected. However, it is better to choose the appropriate camera setting for your scene.

"An image's color is warmer when the Kelvin temperature is lower, and colder when it is higher."

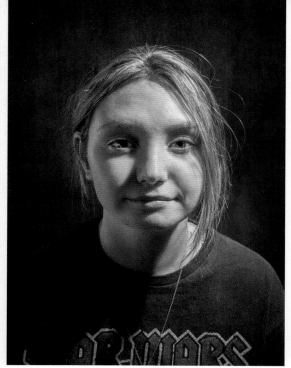

left. **Rembrandt lighting with fill.**

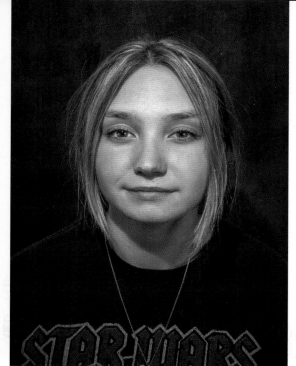

right. **Butterfly lighting.**

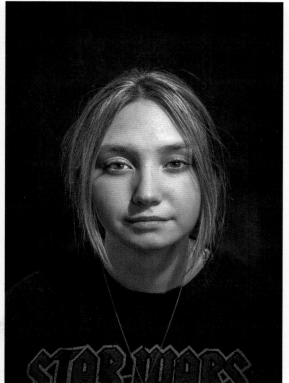

left. **Loop lighting.**

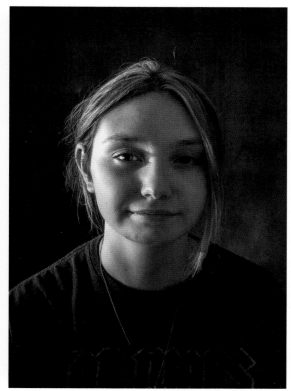

right. **Split lighting.**

5. It's All About the Apps

The Native Camera App

Many of us use our native iPhone camera app. There is nothing wrong with that. The stock camera app is great! It is easily accessible, tied to a hot key (side button), and is perfect for that quick snapshot or occasional dreaded bathroom selfie.

Your stock camera app does more for you than you realize. Once you press that shutter button, the iPhone's software makes automatic adjustments to correct things like exposure, contrast, color, and sharpness. You may have taken a horrible photograph, but the camera app saved the day. For most people, this works. But something is still lacking. Sure, you can edit these images, and many apps have built-in features such as filters, cropping, and the ability to make minor exposure corrections. Many iPhones now have Portrait mode, which allows users the ability to manipulate images via a simulated aperture and digitally apply a background blur.

However, if you want to have more control over your photos, and if you want to take higher-quality images, then you will need to use an application that allows you to take pictures in a RAW (.dng) format. Google "iPhone Camera Raw," and an array of apps will pop up. Deciding which ones work best can be daunting, and each has its limitations. Which application you choose to use is up to you, and there is no right or wrong answer. I recommend that you find one that offers the ability to manually adjust the ISO, shutter speed, aperture, and other functions.

Third-Party Apps

Lightroom Mobile Photo Editor.
The Lightroom mobile photo editor is part of Adobe's Creative Cloud lineup and integrates with Photoshop Express, Spark, and Illustrator. You can also use it to shoot RAW and JPEG formats.

" . . . the iPhone's software makes automatic adjustments to correct things like exposure, contrast, color, and sharpness."

Although the app is free, you will need an Adobe subscription to unlock all of the editing tools.

The great thing about having an Adobe Creative Cloud subscription is that images shot in the Lightroom app, or imported into the program, will be available on your computer via the Lightroom CC desktop app. This offers great flexibility in editing your iPhone images. You can perform quick edits on your phone and immediately share them with friends and family.

If you are syncing with the Creative Cloud, you can open your photographs from your computer and use Lightroom Classic or Photoshop's full editing capabilities to make those final images pop.

ProCamera. Cocologics' ProCamera app is phenomenal. I use it more than any other camera app; it even replaced Lightroom as my go-to camera program. With ProCamera, you can take images in all of the formats—RAW, JPEG, HEIF, and TIFF. There is a subscription associated with ProCamera, and there are a few additional add-ons that can be purchased.

Users also have the option to determine output image crop. Most phones shoot in a native 4:3 ratio, but ProCamera also allows users to choose between 3:2 (standard full-frame format), 16:9,

Native Camera App

Camera Apps

1:1, 3:1, 5:4, or customized dimensions. Not all file formats are available for every crop size, however. But ProCamera does offer something that not many other camera applications offer: the ability to shoot in TIFF with a front-facing camera. Many camera apps are limited to only shooting in JPEG when using this feature.

Similar to a native phone app, ProCamera offers some editing options. Users can choose where images are saved. This includes directly saving photos to a Creative Cloud folder. One can also directly import RAW images from ProCamera to Lightroom for editing and syncing.

Profoto and TricCam. If you are using external flash units to light your portraits, you may need to lean on apps like Profoto or TricCam. These products are game-changers regarding iPhone photography, but they come with a slight learning curve. I cover them more in-depth in a later chapter (see pages 121–122).

"If you are using external flash units to light your portraits, you may need to lean on apps like Profoto or TricCam."

It is worth noting that both apps permit you to capture images in RAW format, while allowing you the opportunity to exert creative control over portrait lighting. With these options, you can maximize the quality of the photos you can create with your iPhone camera.

Moment. This phenomenal camera app allows users to shoot in RAW, JPEG, HEIF, and TIFF. The app is free, but it is optimized for Moment lenses. Later in the book, I describe using after-market lenses and their benefits for several of my shoots. While they are certainly not required to take quality images, they provide opportunities not available with native iPhone camera lenses. It is also not necessary to use Moment's app to have the benefit of their external lenses, but their application allows you to select which lens you are using to ensure image focus and optimization. The app also provides users with limited options for photo editing.

Halide. This is another app that is worth checking out, but you will need to purchase it. Like other apps, Halide will take photos in RAW, JPEG, HEIF, and TIFF. However, the benefit of Halide is that it is known for having one of the best artificial intelligence (AI) software programs. The app has a depth function that will create an artificial blur in front-camera and rear-camera

images, so it is a good choice for portraits and selfies.

Lume-X. While not a required app, Lume-X is an excellent tool if you are using one of the many Lume Cube lighting products. It allows you to monitor the lighting device's status, connect and control multiple devices at once, and register products. The Lume Cube 2.0 can act as an off-camera flash, but it yields better results as constant lighting. The light can be mounted directly to the iPhone, light stand, or can be handheld. The great benefit of using even the smallest Lume Cube is light intensity from a single device. They are also waterproof after installing an optional

seal kit. The application allows you to take pictures, as well; however, the only format available is JPEG.

Choosing the Right Apps

What do each of these third-party apps have in common? In a word, versatility. Each app offers unique benefits, and no single app is ideal for every situation. If you are used to quickly accessing your native phone camera app, it will take some time to consciously think about opening a different one and to determine which one is most beneficial for your situation. This is not a bad thing, as it forces you to take time to think about what you want to shoot. Planning is critical to taking great photos, especially when you are photographing people.

Apps are tools, and you will find yourself using the same three to five tools each time you take photos—partially out of habit, but also because you know what works best for your style. One final benefit to any one of these applications is that they will either directly sync with Creative Cloud or give you the ability to import photos

"Apps are tools, and you will find yourself using the same three to five tools each time you take photos . . . "

into the Lightroom mobile photo editor, edit, and sync your photos with your computer. Most of the apps also allow the user some manual control over their camera settings. In the end, remember limitations when it comes to thinking about apps, and be familiar with what each one can do for you.

Editing

Editing allows the photographer to tie everything together. Remember that when you take a photo in JPEG, your camera decides what the best adjustments are. This is a mathematical calculation, and it doesn't always yield the desired result. For example, you may want to take a silhouetted photo with a shadowy outline of a person in the foreground and a beautiful sunset in the background. To you, this is gorgeous. The computer tasked with making the adjustment knows part of the scene is exposed correctly, while the rest is dark. Therefore, it will automatically make adjustments to open up the foreground. If the camera app makes automatic adjustments and creates a JPEG, you may not be able to make that image look the way you intended.

There are industry standards when it comes to editing. Lots of photographers strictly adhere to those standards. Many photographers break those rules.

Editing is subjective. Therefore, I don't emphasize what should or shouldn't be done when editing. The way I like my photos to look is not necessarily how you want yours to appear. While I don't go into detail about how I edit each of my photos, the process I use tends to stay the same. For example, regardless of what camera app I use, I open the Lightroom mobile photo editor and import my RAW files. From here, I can perform quick edits to get an idea of how I want the final product to look. I also use the sync function in Lightroom, which enables me to open the photos on my computer when I get home. From there, I save the RAW files to my hard drive, and then I import them into Lightroom Classic.

In Lightroom Classic, I make minor sharpness, contrast, and white balance adjustments before exporting the photos to Photoshop. Once in Photoshop, I make minor skin smoothening and blemish adjustments. I also make color adjustments and any last-minute light and contrast adjustments before exporting the file into a program like Nik DxO. Once all adjustments are to my liking, I save the final image for sharing or printing.

6. People

"A thing that you see in my pictures is that I was not afraid to fall in love with these people."

—Annie Leibovitz

The style of photograph you take is not near as important as how that image resonates with the person you are photographing. As an artist and photographer, I focus on multiple concepts when photographing people. However, one of the most significant challenges to photographing people is finding a way to capture their likeness and essence. Sometimes, that is easier said than done. If I cannot readily identify with someone, I will try to focus on capturing a side of them they are not accustomed to seeing. However, art is subjective, and there is a gamble in that logic. Your vision of beauty, for example, may not be the same one someone else identifies with.

How can we identify with people? For me, identifying with people is a challenge unless I know them. Shocker, right? However, I prefer to take photos of people as they are, and in their natural environment. I forgo the formal poses and take a photo of what makes that person unique. That is not to say that posing someone doesn't work. That is the artistic side of photographing people, and it is often where you have the most fun as a photographer.

Learn to be confident in taking photos indoors and out. Maybe the goal is to take an artistic image. Perhaps the goal is to depict something in a person that can only be obtained from an indoor shoot. Regardless of which style you opt for, be sure that it enhances who that person is. Wrinkles, hairstyle, age, eyes, clothing, and the list goes on. When you take photos of people, you tell a story. Their story.

For these shoots, a combination of the following equipment and techniques were used:

• iPhone XS
• iPhone native lens

"Learn to be confident in taking photos indoors and out."

- Moment 58mm lens attachment
- Light stands
- Profoto C1 Plus external light
- Tric flash trigger
- Speedlights
- 9-inch portable softbox
- Westcott X-Drop and conventional backdrop system
- Lume Cube 2.0
- ProCamera app
- Profoto camera app (for use with the Profoto C1 Plus Light), Camera Raw format, and automatic ISO and shutter speed adjustments
- TricCam app (for use with the Tric flash trigger and speedlights); Camera Raw format, and manual light ISO and shutter speed adjustments
- Adobe Lightroom mobile photo editor
- At-home editing: Adobe Lightroom CC, Adobe Lightroom, Photoshop, and Nik DxO

Light Placement & Camera Settings

Off-camera light was used on all shots except when noted. Off-camera lighting was used outdoors to properly expose each subject when they were in shadows or in scenes with strong background lighting. The ProCamera and Profoto apps were set to use auto exposure. When used, the Profoto C1 Pro lighting unit was set to produce maximum output, and the camera exposure was adjusted via an exposure value (EV) correction of between −1.7 and −0.8.

The TricCam app requires manual adjustments for the iPhone XS. Manual ISO settings were between 25 and 200, and shutter speeds were between $1/30$ and $1/45$ second. In some cases, Tric shutter speeds were set as high as $1/125$ second; however, Tric does not offer high-speed sync options, and there are occasions when the flash and shutter do not match.

Keeping it Natural

I often choose people to photograph whom I have a relationship with. This makes setting the scene a little easier. I am used to their mannerisms and style. I often understand what their likes and self-conscious concerns are. Regardless of who the subject is, however, I like to focus on their eyes and smile.

I chose one of my close friends for this shoot because she, like me, is reserved about having her picture taken. These are the type of subjects I love to photograph the most. Why? It is a challenge to me that is often very rewarding. It is my opportunity to take a photo of someone as they are and highlight all their qualities and characteristics. I want them to see things inside

themselves that they are not used to seeing.

I had in mind an array of shots for this friend. So, we started at a local lake. In all honesty, I had no idea how the photos would turn out. The lake is often a busy public place, and taking pictures uninterrupted can be a challenge. Wind and weather can also be unpredictable around large bodies of water. It was a gamble, and one that worked out nicely in this instance.

The day was overcast, hot, humid, and windy. However, a series of shots underneath a covered dock produced

left. Image 6.1.
below. Image 6.2.

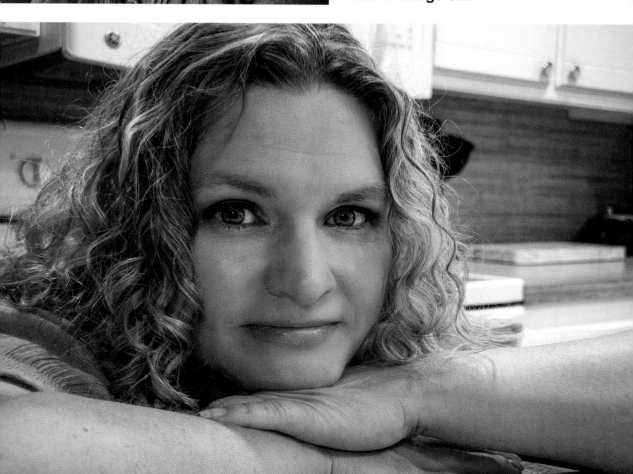

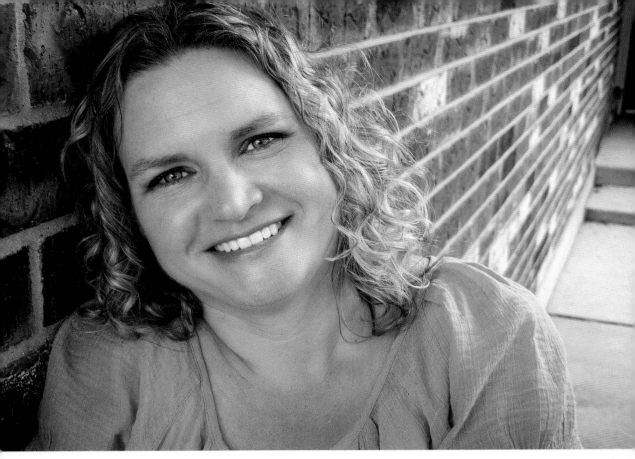

above. **Image 6.3.**
right. **Image 6.4.**

nice images. The one thing I wanted to highlight on this person was her smile and eyes. These are two of her best traits. Ensuring focus and light placement was key. See image 6.1.

Photos don't have to be formal. They don't have to be the same pose over and over. One of the exciting parts about taking photos is experimenting. We ventured back to my friend's home to take a few more indoor and outdoor shots. I also had an idea for a few close-up shots with her head resting on

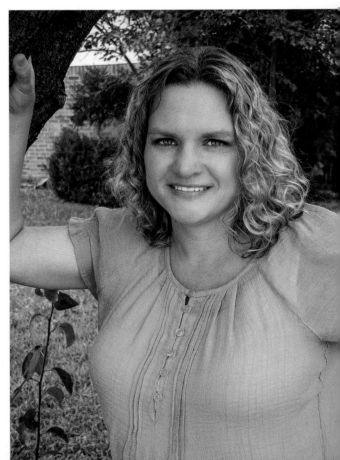

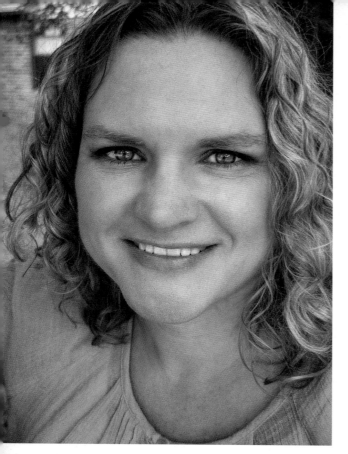

top. **Image 6.5.**
bottom. **Image 6.6.**

her hands while they were placed on a countertop or table. The shot was informal, impromptu, and yet it still accentuates her qualities and traits. See image 6.2.

Finally, I asked my friend to pose outdoors in a few different locations. If you cannot capture people doing something they normally do (e.g., gardening), then ask them to pose in various locations around their home. These are areas they are familiar with and a setting they are comfortable in. As a result, they are often more relaxed and have a natural appearance. You are also more likely to get a nicer smile, and ideally, the shot you sought. See images 6.3–6.6.

Highlighting Their Style

I knew I wanted a country-type theme for one of my shoots. I contacted a close friend and asked her to sit in for a few poses. She is a gorgeous woman with flowing hair, a prominent radiance, and well-defined features. Her home is in a rural part of the state, and she embraces country living and the associated attire.

I had no idea how I would conduct the shoot, other than that I wanted a

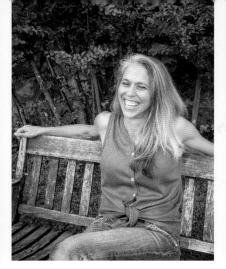 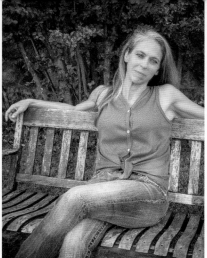 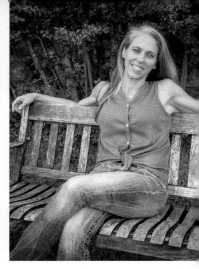

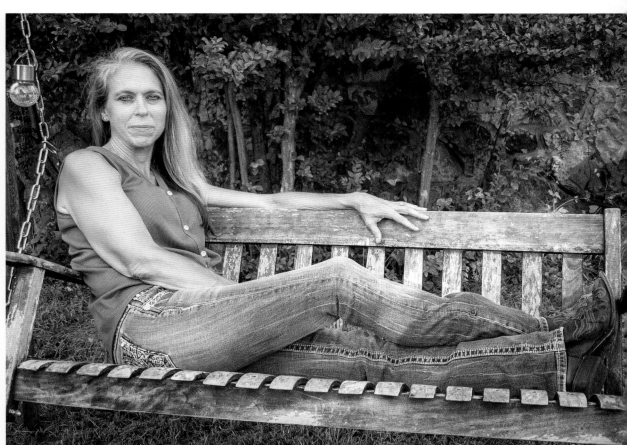

top row. Images 6.7, 6.8, and 6.9.

bottom. Image 6.10.

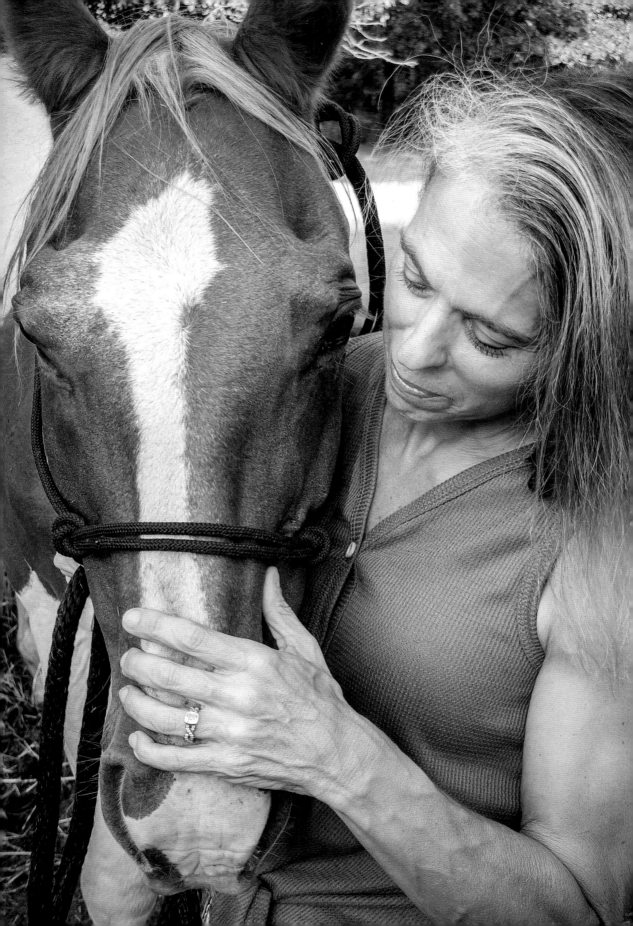

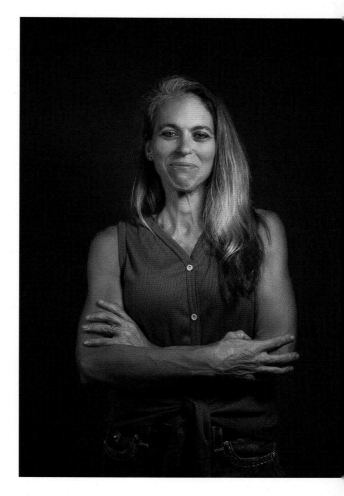

specific theme. However, when I arrived, there was a wooden swing on the front lawn. It screamed country living. The subject's appearance, combined with the scene, was perfect. So, I capitalized on the opportunity and had her sit on the swing. This was, and always is, a perfect opportunity to play with different poses. In many instances, I coached her through smiles and body language. I also let her do her own thing. The trick is quickly identifying that moment worthy of being captured.

As you look at the first four images (6.7–6.10), pay close attention to all of the details. Notice how the scene is framed. How does the subject relate to everything around her? Does everything seem to fit? As we worked through shots, I was lucky and caught an image of her leaning forward and laughing. So natural. Even though it was not a posed shot, it suits the scene. Each subsequent image also identifies with the theme of the shoot. One gains a sense of who she is.

It would not be a country-themed shoot without animals, so I asked my friend if she would mind posing with one of her horses. A word of caution, and something I was keenly aware of, is that when you are interacting with animals, you are placing them in unfamiliar situations. Strange objects are thrust into their personal space. It is important to cease the shoot if you recognize that either subject becomes uneasy. However, in this shot (image 6.11), things came together nicely.

Finally, I wanted to take a few artistic photos. Something that still identifies who my friend is and enhances certain qualities she is not used to seeing. We moved indoors, tried a few poses and

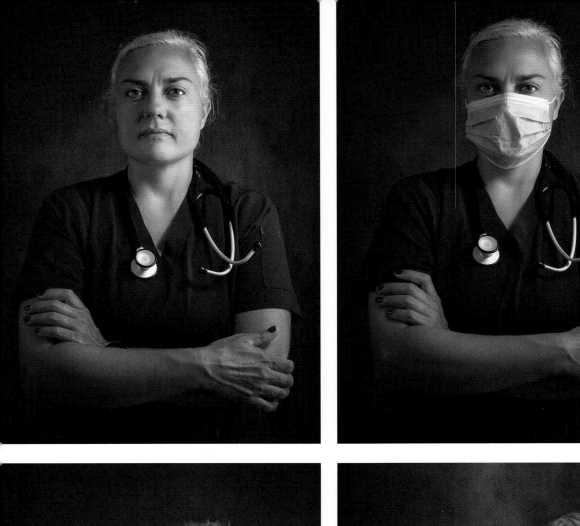
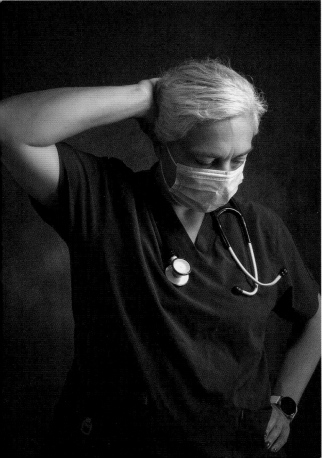
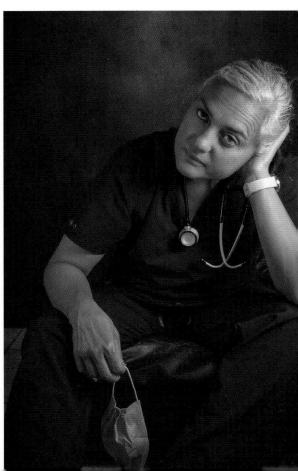

different lighting styles until I captured an image with a smile that I loved (image 6.12). The result: beautiful photos that she will be proud to show off.

Style Can Be Identified with a Profession

I sought to do something special for this shoot, and I asked a friend in the nursing field to let me take a few photos of her. With the current challenges of COVID-19, I wanted a themed shoot that told the story of a healthcare worker. I sought to enhance this woman's traits and portray something we don't often see. I asked her to pose in uniform, as I strived to re-create a level of fatigue and frustration that the public does not usually see. The downside is that it's not easy to take photos of such emotion when it is staged.

At first, we did a few shots without her wearing a mask. I wanted people to be able to see her face—the face of a healthcare worker. This friend has beautiful eyes, and it is a feature that I wanted to draw focus to. The eyes alone convey emotion and tell a compelling story in the first image (6.13).

I asked her to put a mask on after a few poses. The purpose was two-fold. The first was to create the identity that healthcare workers are associated with. The second was to isolate her eyes, as it was the feature I most wanted to draw attention to (image 6.14). Her eyes, however, are not the focus in the final two images (6.15 and 6.16); rather, it is the theme of fatigue and frustration. While it is difficult to re-create that level of realism outside of an ER, the feeling and emotion are identifiable in these portraits.

" . . . the feeling and emotion are identifiable in these portraits."

previous page, top left. **Image 6.13.**
previous page, top right. **Image 6.14.**
previous page, bottom left. **Image 6.15.**
previous page, bottom right. **Image 6.16.**

7. The Teenage Years

Photographers will tell you that their family members are their best models. They are always around. Also, they are the people we take photos of most often. When I first began photography, I was interested in merely capturing the moment. This was no different than what my parents did years ago. Now those pictures have a permanent residence inside photo albums. However, unlike my parents' photos, mine were confined to an iPhone.

I eventually found that my kids were my greatest asset when it came to progressing as a photographer. I learned I could take pictures of them while practicing new techniques. Recently, I did what every good photographer and parent does. I dragged my kids to the local park to exploit them. My daughter is always enthusiastic; my son participates when I insist that he must. However, the allure of being in print had not eluded them. They are teens now, and are easier to photograph than they were when they were younger. I can count on them to sit still when needed. I can also catch their random acts of goofiness.

For these shots, a combination of the following equipment and techniques were used:

- iPhone XS
- iPhone stock lens
- Moment 58mm and 18mm lens attachments
- Light stands
- Profoto C1 Plus external light
- Tric flash trigger
- Speedlights
- Godox 47-inch octagon softbox
- Westcott X-Drop and conventional backdrop system
- Lume Cube 2.0
- ProCamera app
- Profoto Camera app (for use with the Profoto C1 Plus light), Camera Raw format, and automatic ISO and shutter speed adjustments
- TricCam app (for use with the Tric flash trigger and speedlights); Camera Raw format, and manual light ISO and shutter speed adjustments
- Adobe Lightroom mobile photo editor
- At-home editing: Adobe Lightroom CC, Adobe Lightroom, and Photoshop

Light Placement & Camera Settings

Off-camera light was used on all shots except when noted. Off-camera lighting was used outdoors to properly expose each subject when they were in shadows or in scenes with strong background lighting. ProCamera and Profoto apps were set to use auto exposure. When used, the Profoto C1 Pro lighting unit was set to produce maximum output, and the camera exposure was adjusted via an exposure value (EV) correction of between –1.7 and –0.8.

The TricCam app requires manual adjustments for the iPhone XS. Manual ISO settings were between 25 and 200, and shutter speeds were between $1/30$ and $1/45$ second. In some cases, Tric shutter speeds were set as high as $1/125$ second; however, Tric does not offer high-speed sync options, and there are occasions when the flash and shutter do not match.

Teenage Boys

Every teen is different, and my son is one of the more difficult teens I have photographed, though it has gotten easier with age. I try to focus on capturing him in more natural settings, as posing causes him to feel self-conscious.

For the first shot, I wanted to try something unique. I used a tree as a

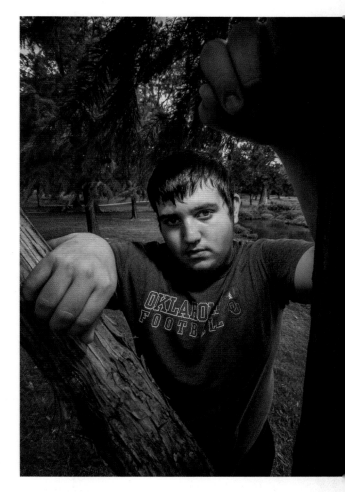

above. Image 7.1.

framing device, and I chose to work with the 18mm Moment lens for an elongated perspective. Because of my position, I hand-held the Profoto C1 Plus. I positioned the light six to eight inches away from my son at approximately a 45-degree angle and to his left, and just above eye level (image 7.1).

"I chose to work with the 18mm Moment lens for an elongated perspective."

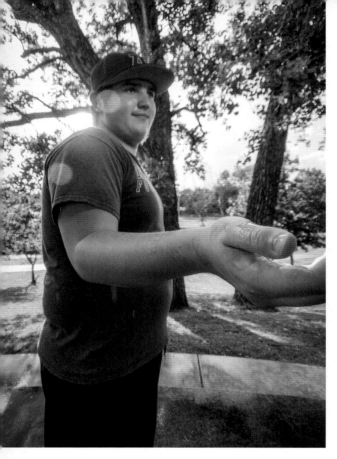

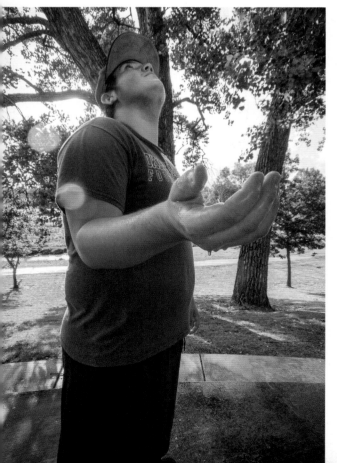

top. Image 7.2.
bottom. Image 7.3.
following page. Image 7.4.

Achieving the best lighting effect is a process of trial and error. As you work, be sure to take a few shots until you get a look you are happy with.

We moved locations and found a gazebo of sorts. While inspecting the platform, I noticed my son was playing in the rain that was falling from an overhead awning. This was an opportunity to capture him in a random moment. Unscripted actions make for some of the best shots.

I attached the Profoto C1 to a light stand and left the Moment 18mm lens attached. I watched him play in the rain for a little while, and kept an eye on the expressions on his face as he interacted with his sister, who was off-camera. I was able to take a few photos of him playing in the runoff. See images 7.2 and 7.3.

I wanted at least one portrait of each of my kids. The gazebo location was perfect. I had my son sit against a column and took a few shots, but they were not working for me. So, I played with a few angles. I got close, backed up, and moved the light, but nothing was catching my eye. It was right about then, most likely out of boredom, that

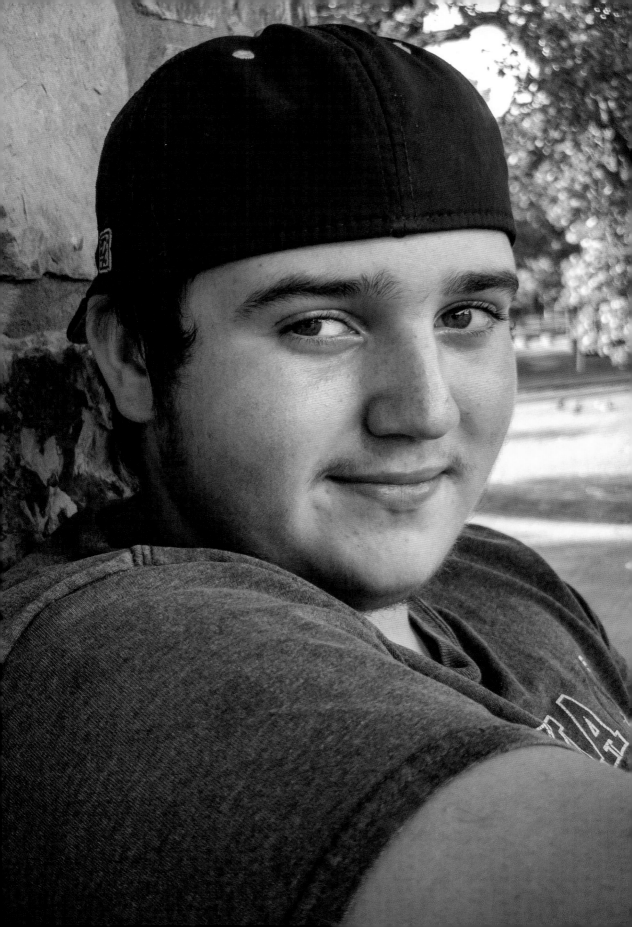

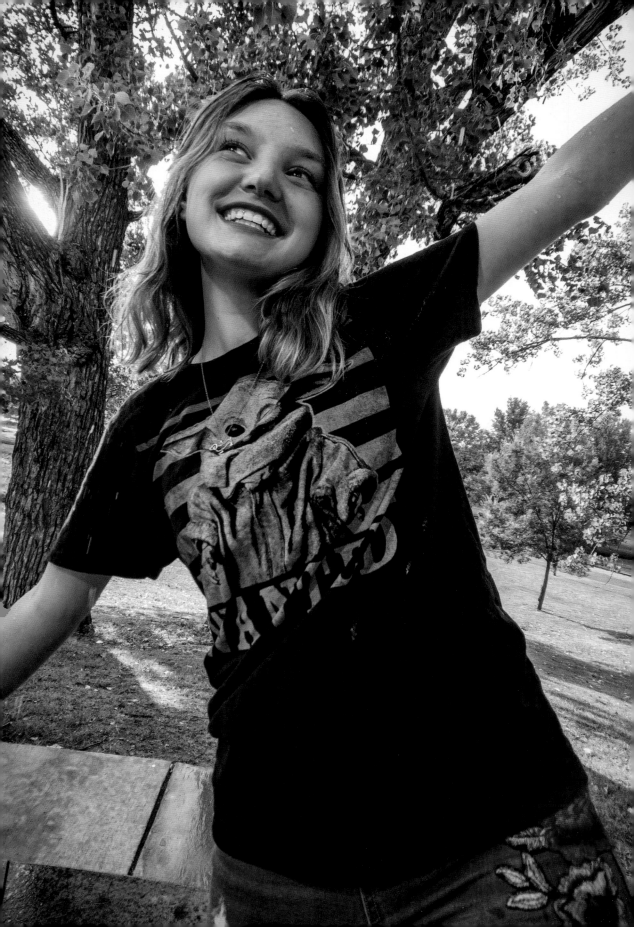

> ## *"In this case, I wanted the perception distortion created by the 18mm lens."*

he turned his hat around. This was not something he usually does. With a little coaxing, I was able to get him to crack a smile. I positioned the light about six to eight inches away from my son at approximately a 45-degree angle and to his left, just above eye level. I did not want any distortion for the shot, so I changed to a 58mm lens. This also gave the background a nice blur (image 7.4).

Teenage Girls

My daughter is a bit more photogenic than my son, and she is often eager to participate. I seldom worry about positioning her, and I let her pose on her own. Unless her choice is something less than desirable, I rarely offer suggestions. Again, my goal is to let kids be themselves and to capture moments.

The first shot of my daughter took a little coaching. The lighting was still set up from when I photographed my son playing in the rain, and I asked my daughter to act silly. This was a bit of a challenge for her, as she was being

previous page. Image 7.5.
top. Image 7.6.
bottom. Image 7.7.

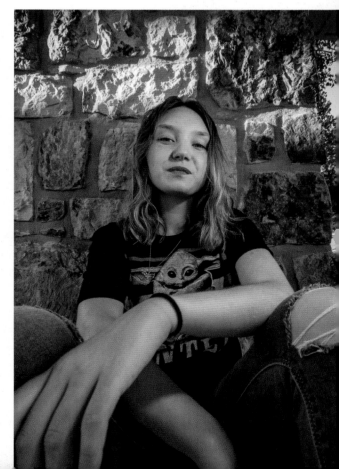

tasked with doing something specific, rather than just being herself. However, her efforts paid off. I also wanted to create a distorted perspective and used an 18mm lens. See image 7.5.

The next series of shots of my daughter were ideal impromptu moments. She sat down to take a break, and I observed her using her phone. I positioned the light about six to eight inches away from my daughter at approximately a 45-degree angle to her left, and just above eye level. However, I wanted to get something different with a shot of her sitting against the column. I left the 18mm lens attached and took several shots of her centered in the frame. To gain a different perspective, I placed the iPhone down low and looking upward from her feet. From this vantage point, one can see how much distortion is created by a wide-angle lens. I moved in for a few close-up shots and used the same light setup.

My daughter's portrait was similar in fashion to my son's. However, this time, I moved the lighting unit slightly to her right based on how she was sitting. It was positioned above the eyes, as in previous shots. I used a 58mm lens to minimize distortion. See image 7.7.

My daughter is comfortable in posing, so I can readily capture a variety of pictures of her from different angles.

Together

These are authentic snapshot images—the kind that capture everything and

below. **Image 7.7.**

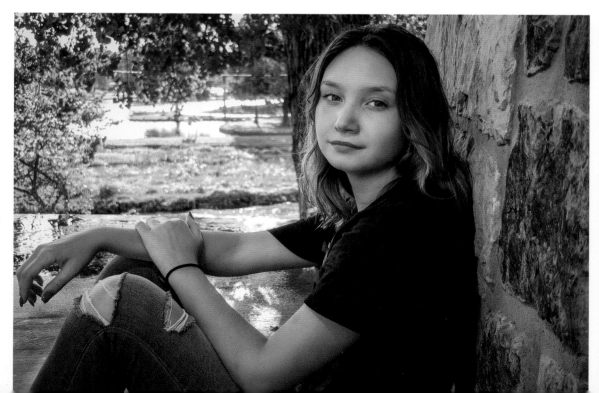

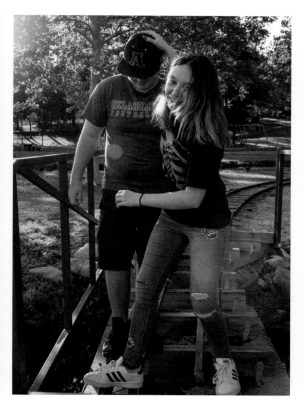

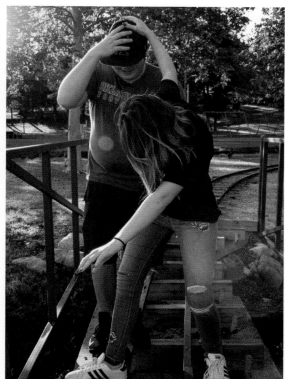

top left. Image 7.8.
top right. Image 7.9.
bottom. Image 7.10.

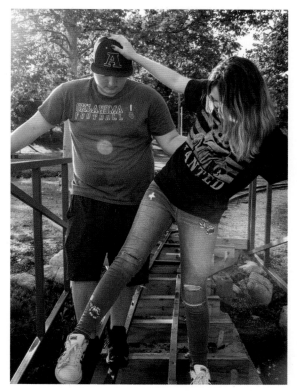

anything without a specific pose or purpose. I knew both of my kids would interact playfully if I had them walk down a small set of train tracks at the park. The results were exactly as I had expected. In this instance, I was merely the observer. I removed all lens attachments and ensured both of my kids completely filled the frame for each shot. I ended up with several memorable images of them acting like a typical brother and sister. See images 7.8–7.10.

In the Studio

I wanted to take some studio portraits of my son using a few different lighting techniques. I used a combination of key, fill, and backlighting. Getting my son to smile and stand still is always a challenge. So, my goal in this shoot was to test the abilities of the TricCam app and flash trigger. The photos turned out nicely even with a minimal smile, teenage scruff, and a freshly wrinkled shirt.

top. Image 7.11.
bottom. Image 7.12.

8. Family Sessions

Today's family can be highly diversified. It is a culture in and of itself. There are no age limits. No maximum or minimum sizes. No boundaries regarding patriarchal or matriarchal figures. They are a mix of sexes, identities, beliefs (both ideological and theological), genetic backgrounds, and races. Each one is different from the next, and it is possible to have more diversity in one household than on a given city block.

There are more challenges when photographing a family than there are when working with an individual. You are tasked with determining what captures that group's essence rather than a singular person. Some family photos are very creatively done. I have seen those that highlight the fun, as well as the chaos, in a family unit. I have also seen

"There are more challenges when photographing a family than there are when working with an individual."

photos in which the layout is always the same, regardless of the family dynamic: Mom, Dad, and a kid or two, hand in hand, or standing in a field smiling for the camera. Sure, it's a nice photo, but does it portray who they are as a family?

For these shots, a combination of the following equipment and techniques were used:

• iPhone XS
• iPhone stock lens
• Moment 58mm, 18mm, and 14mm fisheye lens attachments
• Light stands
• Profoto C1 Plus external light
• Tric flash trigger
• Speedlights
• Godox 47-inch octagon softbox
• Westcott X-Drop and conventional backdrop system
• Lume Cube 2.0
• ProCamera app
• Profoto Camera app (for use with the Profoto C1 Plus Light), Camera Raw format, and automatic ISO and shutter speed adjustments

- TricCam app (for use with the Tric Flash Trigger and speedlights); Camera Raw format, and manual light ISO and shutter speed adjustments
- Adobe Lightroom mobile photo editor
- At-home editing: Adobe Lightroom CC, Adobe Lightroom, Photoshop

Light Placement & Camera Settings

Off-camera light was used on all shots except when noted. Off-camera lighting was used when outdoors to properly expose each subject when they were in the shadows or in scenes with strong background lighting. ProCamera and Profoto apps were set to use auto exposure. When used, the Profoto C1 Pro lighting unit was set to produce maximum output, and the camera exposure was adjusted via an exposure value (EV) correction of between -1.7 and -0.8.

The TricCam app requires manual adjustments for the iPhone XS. Manual ISO settings were between 25 and 200, and shutter speeds were between

$1/30$ and $1/45$ second. In some cases, Tric shutter speeds were set as high as $1/125$ second; however, Tric does not offer high-speed sync options, and there are occasions when the flash and shutter do not match.

The Family in Its Natural Environment

That heading sounds like something from Animal Planet. To me, capturing moments that show how family members usually yields a more realistic representation of them than using staged poses. Posing can make people look uncomfortable, and they may not appear natural. Remember, the purpose of photographing people is to record a moment and create a memory that identifies who these people are.

A family I have known for several years allowed me to spend an afternoon with them and take photographs of them being themselves. They let me linger in the shadows and sometimes be a bit more intrusive, while I observed them having a family cookout. They are a blended and bi-racial family. Each family member has his or her own distinctive personality, and each of them exhibits the traits that make them a unit. Many families are hard to pose, simply because that is not their style. It is not who they are. That was true in this case.

"Off-camera lighting was used when outdoors to properly expose each subject when they were in the shadows . . . "

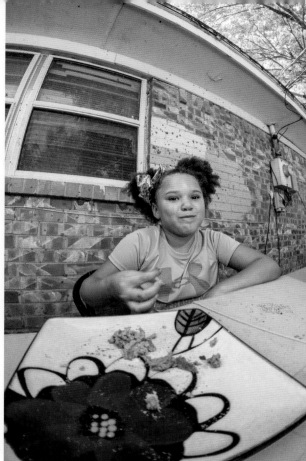

top left. **Image 8.1.**
top right. **Image 8.2.**
bottom. **Image 8.3.**

The focus of this shoot was to capture those moments that say, "This is who we are," and preserve the moments that tend to be lost to memory over time. Those little things that almost no one is likely to remember in five or ten years. My task was easy because I was familiar with the family and how they interact with one another. I wanted to capture those random snapshot moments. I wanted nothing posed, outside of a little coercing. Snapshots

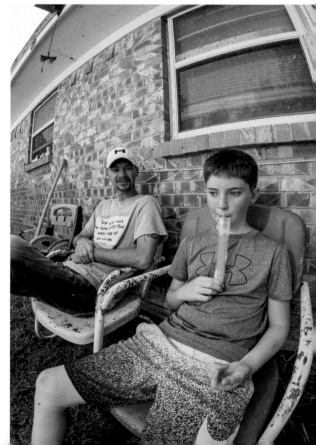

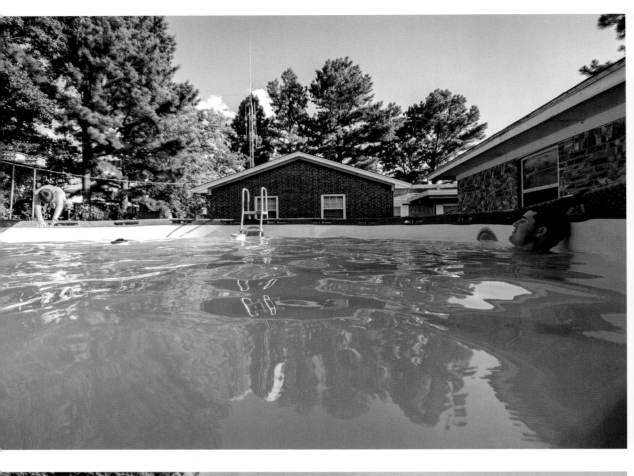
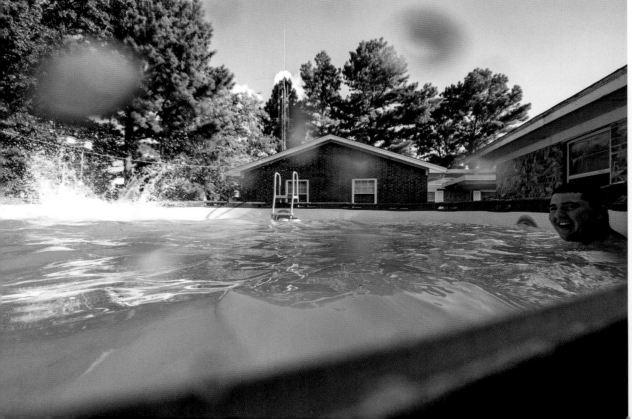

are intended to be quick and spur of the moment. That is not to say that one shouldn't take time to think about the scene they are trying to photograph. It is important to focus on things like composition, lighting, and to be mindful of what else is going on in relation to your subject.

The first several images are what I like to refer to as classics. This is a family being a family. These were not intended to be serious poses, so I used an 18mm lens to create a little lens distortion and make the shots a little more fun. I wanted an elongated look to the photos. I also used a 14mm fisheye attachment for a few of the images.

The topic of the family chickens came up a few times. I had the family bring a few over to photograph one of these moments. I mean, what else can you say? They were a great addition to the photo. More importantly, it was not something people see daily. Never forget who your main subject is intended to be. In this case, is it the dad or the chicken? Would the scene be any less interesting if the focus changed from one subject to the other? See image 8.1.

Of course, it wouldn't be a cookout without food. I watched one of the kids

previous page, top. **Image 8.4.**
previous page, bottom. **Image 8.5.**
following page. **Image 8.6.**

"One advantage that many smartphones have over DSLR cameras is that several models are water resistant."

eating and acting silly. So, I changed from an 18mm to a 14mm fisheye lens. This kid has a unique personality. She can go from being camera shy one minute to taking center stage the next. See image 8.2.

This is a perfect time to let a child be themselves and photograph whatever random moments arise. I was even able to photograph one of the other kids taking a break and enjoying a Popsicle. See image 8.3. These are trivial moments to the kids, but memorable ones for Mom and Dad.

A backyard cookout would not be complete without a dip in the pool. One advantage that iPhones have over DSLR cameras is that they are water resistant. While the Moment lenses are neither water-resistant or waterproof, a little splash here and there doesn't hurt them. A bit of water certainly does not affect the iPhone XS. I jumped at the opportunity to get close to the action and photograph the kids playing in the pool. Keep in mind that the scene can change rapidly when you are working

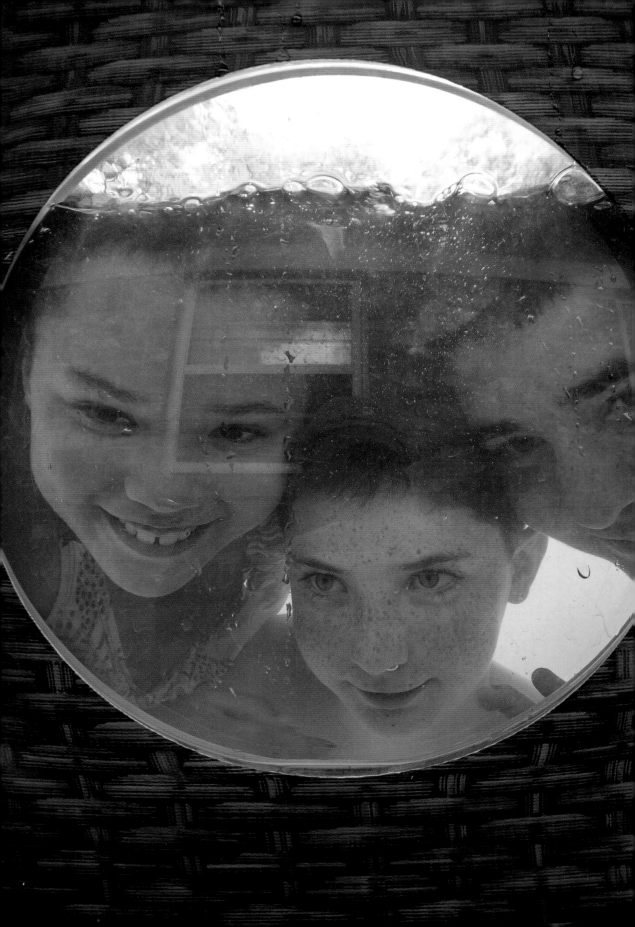

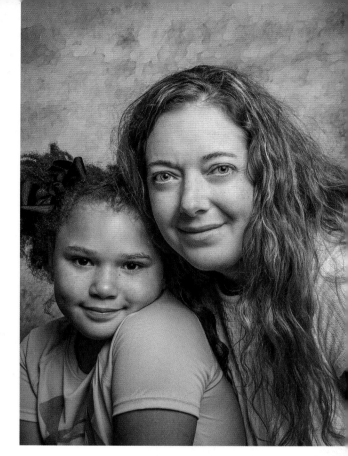

outdoors. I always pay attention to where my focus point should be and where my subjects are located within the frame. See image 8.4 and 8.5.

A unique opportunity presented itself when I noticed a series of small portholes in the side of the pool. This was a chance to take a photo of something different. I had all three kids go underwater, put their faces in the porthole, and I took a number of photos as quickly as I could. You never know how long moments like this may last.

The porthole made for a perfect framing device. In situations like these, it's okay to get a little of the photographer's reflection in the scene. See image 8.6.

I wanted to do something special for this family, as well. We ventured inside, and I set up a backdrop to take a few family portraits. I wanted something a little more formal, and yet still informal. At first, I had Mom and her daughter take a few pictures together.

> *"I had all three kids go underwater, put their faces in the porthole, and I took a number of photos as quickly as I could."*

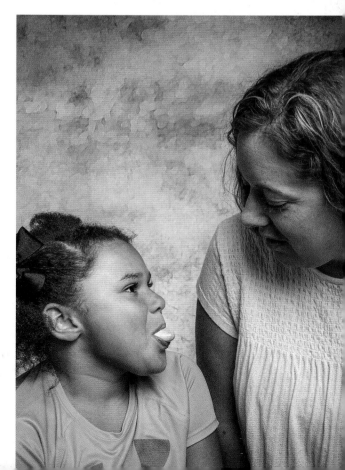

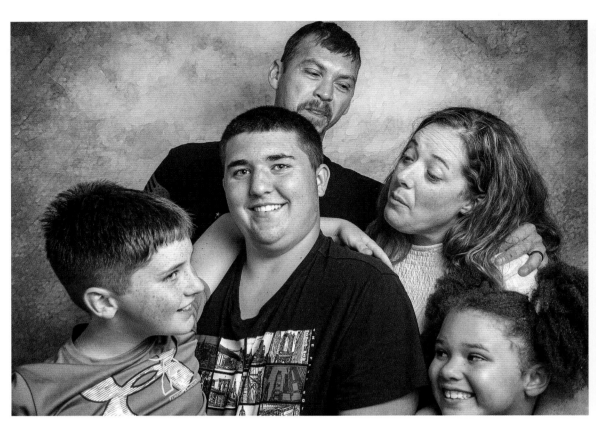
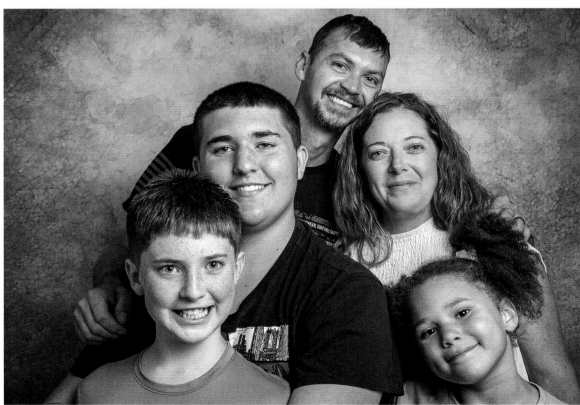

previous page, top. **Image 8.9.**
previous page, bottom. **Image 8.10.**

I asked them to try a few poses, but then I sat back and watched as they did their own thing. I think you can guess which image was posed, and which was a random moment. Both images came out great, and they illustrate the special relationship between a mother and her child. See images 8.7 and 8.8.

Finally, I wanted to photograph the family together. I certainly got what I was looking for. The first image could not have been timed better. This is exactly what I strive to achieve when I photograph families. This is that photo that says, "This is who we are." The kids crammed in and did what kids do best. Mom, a little frustrated, was attempting to wrangle everyone together. And Dad? Well, he did what dads do best; he played the silent observer. I got both Mom and Dad to join in the chaos with a bit of coaching. I feel that the lone son in the center, casually smiling as if this is the family norm, makes the picture priceless. See image 8.9.

I was also able to photograph a more serene family moment. In image 8.10, there is no chaos, no turmoil. It is a different kind of image that clearly shows this is a family that cares deeply for one another. These are the moments that are hard to portray when out in a field, walking on a beach, or meandering down a wooded path.

All of the subjects differed in height. The pyramid-like structure of the group in the final photo is easy for the eyes to follow, and the image exudes strength and harmony.

"The pyramid-like structure of the group in the final photo is easy for the eyes to follow . . . "

9. Couples

Couples can be as challenging to photograph as families. One needs to be able to identify what makes both people individuals, but also what makes them a couple. It is not uncommon to see photos of couples in staged poses. Sure, it makes for a nice photo, but is that really how they are together?

I often create two different types of images when I photograph couples: something with them together that identifies them as a couple, and something artistic. My artistic choices depend on how I feel about a given couple. What kind of rapport do I have with them? How do I see them interacting together as a couple? If these are people who don't typically go out for nature hikes, then I am more likely to photograph them in a familiar setting, such as at a local park, in their home, or in front of a backdrop.

For these images, a combination of the following equipment and techniques were used:

- iPhone XS
- iPhone native lens
- Moment 58mm lens attachment
- Light stands
- Tric flash trigger
- Speedlights
- 9-inch portable softbox
- Godox 47-inch octagon softbox
- Westcott X-Drop and conventional backdrop system
- Lume Cube 2.0
- ProCamera app
- Profoto camera app (for use with the Profoto C1 Plus Light), Camera Raw format, and automatic ISO and shutter speed adjustments
- TricCam app (for use with the Tric flash trigger and speedlights); Camera Raw format, and manual light ISO and shutter speed adjustments
- Adobe Lightroom mobile photo editor
- At-home editing: Adobe Lightroom CC, Adobe Lightroom, and Photoshop

Light Placement & Camera Settings

Off-camera light was used on all shots except when noted. Off-camera lighting was used when outdoors to properly expose each subject when they were in

the shadows or in scenes with strong background lighting. ProCamera and Profoto apps were set to use auto exposure. When used, the Profoto C1 Pro lighting unit was set to produce maximum output, and the camera exposure was adjusted via an exposure value (EV) correction of between –1.7 and –0.8.

The Tric camera app requires manual adjustments for the iPhone XS. Manual ISO settings were between 25 and 200, and shutter speeds were between $1/30$ and $1/45$ second. In some cases, Tric shutter speeds were set as high as $1/125$ second; however, Tric does not offer high-speed sync options, and there are occasions when the flash and shutter do not match.

Separating Them from the Rest of the Family

When I photograph couples, I try to focus on what makes them a unit. They are individuals, but together the relationship has its own dynamic. Some couples put these traits on display, while others are more private in their interactions. This is a fascinating part of capturing couples and finding different ways to get them to be themselves.

Image 9.1 stems from an earlier family shoot. Before conducting indoor sessions, I looked for an opportunity to

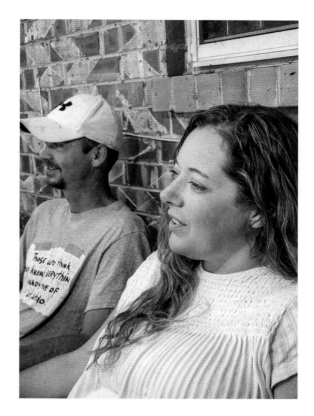

above. Image 9.1.

find this couple in a moment together. This can be a challenge with the hectic atmosphere of a cookout, and the kids doing their own thing. Parents often find themselves spinning in circles, trying to keep everything together, and spend little time relaxing. However, after getting the kids into the pool, I was able to find a moment to take photos of this couple. The scene was nothing fancy, nor was it intended to be. I chose to capitalize on a moment of contentment and relaxation before chaos ensued. This is a moment that many parents can relate to.

A Hot Summer of Love

I convinced my married friends to bear the daunting heat and humidity and allow me to take photos of them one evening. It's important to note that your choice of location is an important aspect when photographing couples. It can amplify their relationship and personalities or make the event an agonizing ordeal. I had an idea of what I wanted to try with these two, and I researched several poses that I felt fit their relationship and personalities. We soon discovered that some of the ideas, however, were not suited to the couple,

top. Image 9.2.
bottom. Image 9.3.

did not work in the location, or both, so we improvised.

At first, I asked the couple to sit on a bench. I tried several different poses until I found ones that fit them. What worked well for this situation was having them lay in different positions on one another. They remained stationary as I walked around them and took photos from multiple angles. As is often the case in a photo shoot, this was an experiment to find what worked. The result was a selection of images that captured a special moment between the pair and highlighted how they interact together and feel about one another. See images 9.2 and 9.3.

I noticed a climbing wall shortly after I arrived. It had an array of colors, textures, and fixtures that could be incorporated into a scene. We made our way over to the wall once we finished shooting on the bench. I had in mind several shots of her with her back to the wall. Maybe a few of her shyly looking away like a slightly embarrassed schoolgirl in love. However, what I envisioned and what transpired were somewhat different. This was another instance in which I photographed a little of what I sought, while the rest resulted from letting them be them. The results were priceless. The two are having fun, and their body language is very natural. More impor-

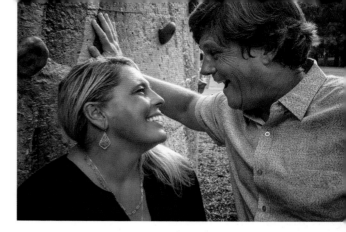

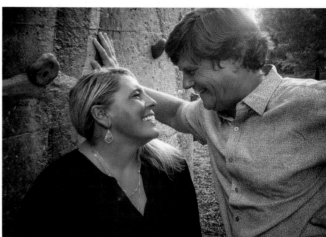

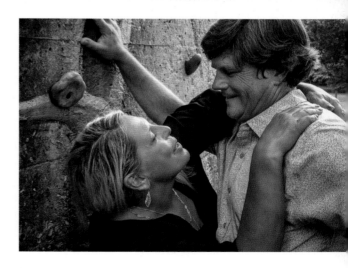

top. Image 9.4.
center. Image 9.5.
bottom. Image 9.6.

tantly, you can see how much they love one another. See images 9.4–9.6.

Each of us was dripping with sweat by the time we got to the climbing wall, and none of us were dry by the time we reached our next location. I knew it would be hard to minimize sweat in the final images. At one point, I joked about dousing them in water to even things out. They took my semi-serious suggestion in stride, and it made the rest of the shoot more comfortable. It also lessened the likelihood that they would need to come back for a reshoot.

So, we set up for our final few shots. With their backs to the sun, I took a few photographs of the couple together in a loving embrace. See images 9.7 and 9.8.

Framing your subjects is only a small part of the equation. How does the scene balance in relation to your subjects? Is there something that takes the focus away from what you want to see? Occasionally, when you review your images after the shoot, you will realize a distraction was present that you had not noticed during the session.

"How does the scene balance to your subjects? Is there something that takes the focus away from what you want to see?"

below. Image 9.7.
following page. Image 9.8.

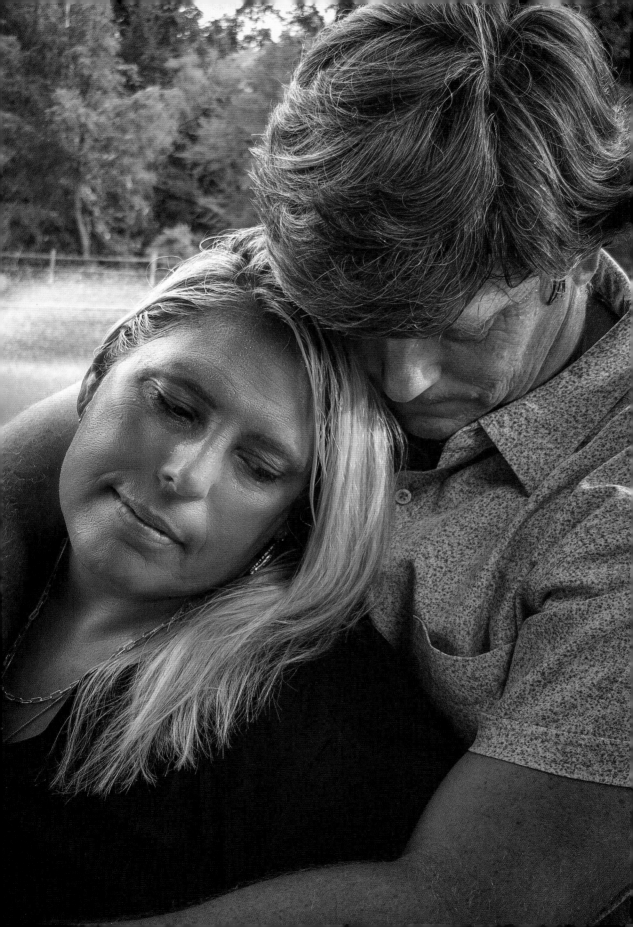

10. Cultural Diversity

Even though I try to maintain a consistent style in my photos, that doesn't mean that my subjects should look identical. We live in a diversified world, and it is wonderful to get the opportunity to capture images with a wide range of beauty and diversity. As I have noted, when I photograph people, I try to enhance what makes them special and unique. I don't want to turn them into a model unless that is what they are, though I don't mind so long as the way they are posed and photographed does not make them look awkward and uncomfortable. That said, it is important to find a way to take photos of that person that highlights their best physical characteristics.

So how do we enhance cultural diversity when presented with the opportunity? Well, there are many ways. It goes well beyond skin tone. We can do

" . . . find a way to take photos of that person that highlights their best physical characteristics."

this with traditional attire representing a given background, or you may have guessed it, by letting our subjects be themselves. When striving to show diversity, create images of that person in a moment that makes them feel special, and one that they think speaks to who they are. I opt to fall back on what always works: I accentuate the beauty I see in the subject. Whether that is their eyes, face, or hair, I want to be sure to draw attention to that trait.

For these shots, a combination of the following equipment and techniques were used:

- iPhone XS
- iPhone stock lens
- Moment 58mm lens
- Light stands
- A Profoto C1 Plus external light
- Tric flash trigger
- Speedlights
- Godox 47-inch octagon softbox
- Westcott X-Drop and conventional backdrop system
- Lume Cube 2.0
- ProCamera app

- Profoto Camera app (for use with the Profoto C1 Plus Light), Camera Raw format, and automatic ISO and shutter speed adjustments
- TricCam app (for use with the Tric flash trigger and speedlights); Camera Raw format, and manual light ISO and shutter speed adjustments
- Adobe Lightroom mobile photo editor
- At-home editing: Adobe Lightroom CC, Adobe Lightroom, and Photoshop

Light Placement & Camera Settings

Off-camera light was used on all shots except when noted. Off-camera lighting was used when outdoors to properly expose each subject when they were in the shadows or in scenes with strong background lighting. ProCamera and Profoto apps were set to use auto exposure. When used, the Profoto C1 Pro lighting unit was set to produce maximum output, and the camera exposure was adjusted via an exposure value (EV) correction of between –1.7 and –0.8.

The TricCam app requires manual adjustments for the iPhone XS. Manual ISO settings were between 25 and 200, and shutter speeds were between $^1/_{30}$ and $^1/_{45}$ second. In some cases, Tric shutter speeds were set as high as $^1/_{125}$ second; however, Tric does not offer high-speed sync options, and there are occasions when the flash and shutter do not match.

This is Native America

I asked one of my closest friends to participate in this shoot. She is of Arapaho heritage and is a gorgeous woman with well-defined features that radiate her beauty and Native American lineage. Native American cultures are as diversified as America is as a whole. Oklahoma has a prominent presence of Native American culture. Thirty-nine tribes call Oklahoma home. This includes the Five Civilized Tribes who were known for their highly developed government and ruling systems: (1) Chickasaw, (2) Choctaw, (3) Cherokees, (4) Creek, and (5) Seminole. However, only five of the thirty-nine tribes are indigenous to Oklahoma: (1) Caddo, (2) Comanche, (3) Kiowa, (4) Osage, and (5) Wichita.

Many Native Americans are tightly bound to their heritage, which includes language, dialect, writing, traditional and ceremonial dress, cooking, song, dance, and an array of other traditions that set each tribe apart from one another. Some may hold tight to tribal values and ancestry, while others adopt more Westernized appearances. Nonetheless, this is diversity at its finest, and one could spend a lifetime studying each tribe's characteristics and traditions.

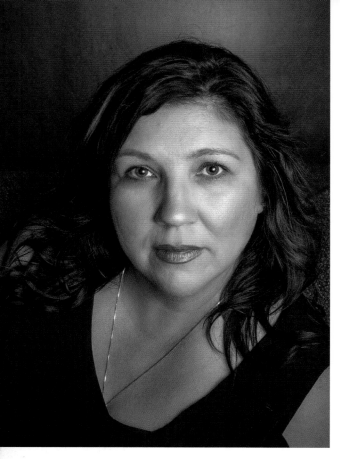

I wanted to take numerous shots with my friend because she is not camera shy. She has stunning eyes. This is not lost on her; they are one of her favorite physical traits. Therefore, my goal for the session was two-fold: to capture images that highlight my friend's Native American features and to take a series of photos that focus on her eyes.

The first few images were intended to be simple. No fancy poses, only images that were designed to get the ball rolling and help her and I loosen up.

We kept to the basics for the first couple of shots, and she sat on a couch while I played with multiple angles. The goal was to use natural poses that accentuated her looks and did not make her look or feel awkward. This was also an excellent opportunity to move the lighting around and find a look I was happy with. I aimed for either a butterfly or loop lighting style. See images 10.1 and 10.2.

I wanted to try something a little different. We moved an elongated

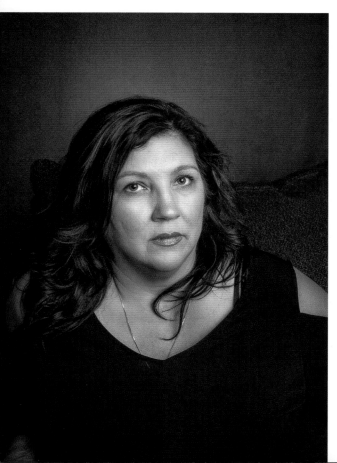

top. Image 10.1.
bottom. Image 10.2.

ottoman, and I had her lie down in a position comfortable to her. The next three images (10.3–10.5) look similar, with slight variances.

In every session, I try to capture at least one image of the person looking and acting as naturally as possible. I like to catch them laughing or grab a shot when they are not aware of the camera. This can take planning. As a photographer, it is your responsibility to ensure that the person you are pho-tographing is comfortable with you and the entire process. However, sometimes we tend to forget this and become

top right. Image 10.3.
bottom left. Image 10.4.
bottom right. Image 10.5.

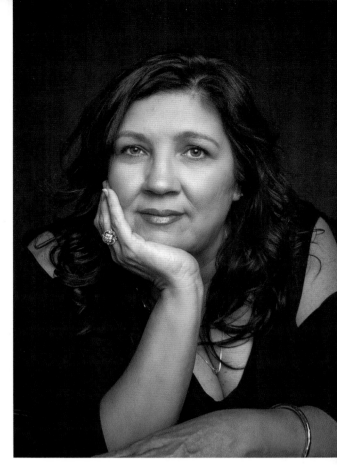

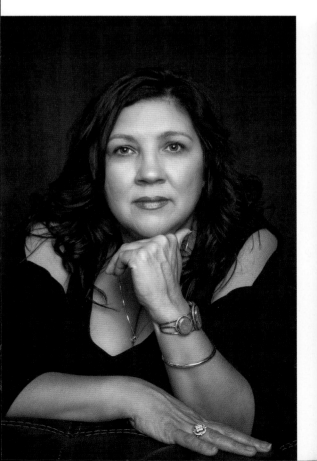

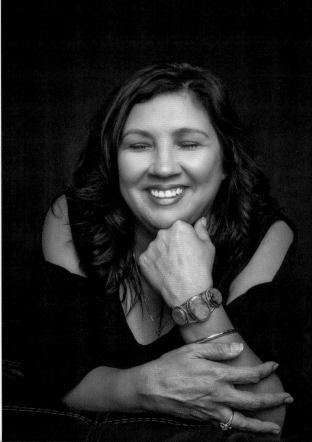

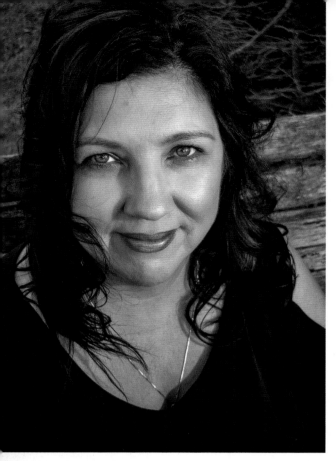

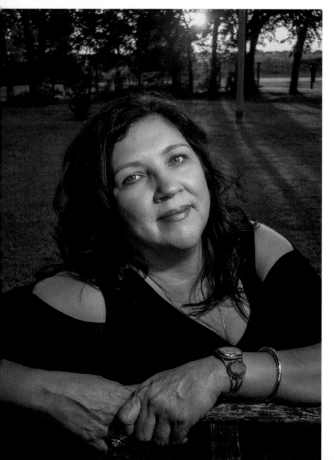

top. Image 10.6.
bottom. Image 10.7.
following page. Image 10.8.

focused on completing the task at hand. Therefore, I try to make it a point to laugh and joke with a subject to help them loosen up. While artistic and stern-looking images are among my favorites, nothing beats photographing a person in the throes of laughter.

We ventured outside to change things up a little. I wanted to incorporate several outdoor elements into the scene, as my friend lives in a rural area.

For the first outdoor shot (image 10.6), I had her sit on an old wooden swing that had an interesting allure. We also tried a few angles. To start, I had her facing the setting sun. A flash was used to balance the light.

For the second shot (image 10.7), I had her turn around to find a position she was comfortable with on the swing. In this case, the sun was setting behind the subject. If I did not compensate for this, she would have been left in the

"The sun was setting behind the subject. If I did not compensate for this, she would have been left in the shadows."

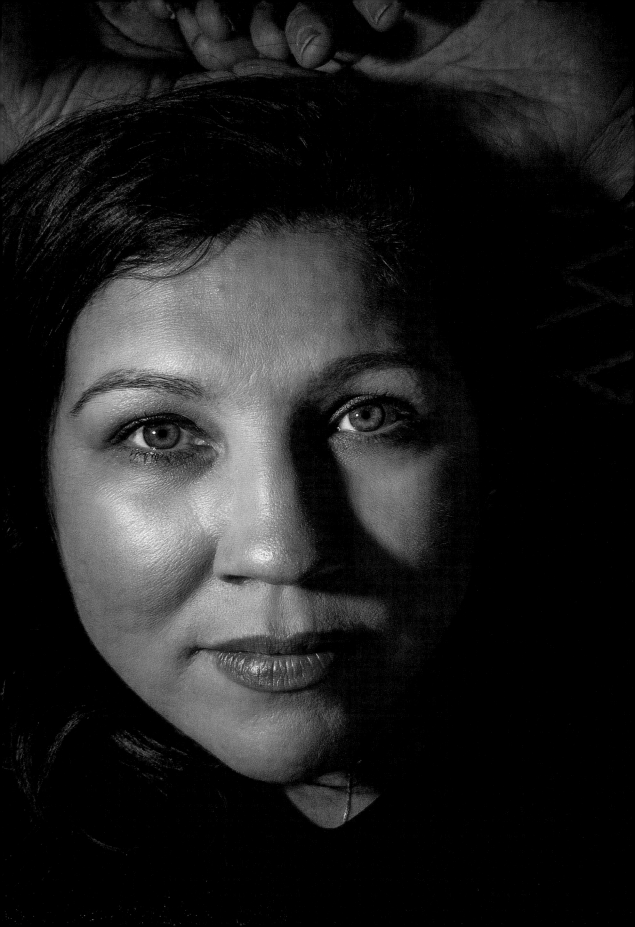

shadows. If I exposed for the subject, then the background would be overexposed. Therefore, I used flash to illuminate the subject and properly expose the background.

I noticed a hammock while we were wrapping up, and I had my friend lie on it. I tried to figure out how to incorporate some of the overhead party lights into the scene for a nice background feature. It did not work out, and I ended up with several experimental shots of her lying in the hammock. Remember to become comfortable with experimenting and do not become discouraged if an idea doesn't work out. I go home with many images that did not work out as I had planned. In this case, one of the photos, image 10.8, was perfect. Wow, those eyes!

Go Pokes!

I sought diversity in my journey to write this book. I wanted to highlight many of the unique characteristics that make us different—those traits that highlight who we are, where we came from, and who we are proud to be. I wanted diversity beyond the sexes and age groups. I wanted cultural diversity that reminds us that while we share this space, we often neglect to pay attention to those differences that make each one of us special.

I have the luxury of working at a university situated on a gorgeous campus. When one of my African American friends jumped at the opportunity to have her photo taken, I knew that incorporating something related to the university would be perfect. The campus would offer a different setting, and it is also symbolic of something she loves.

Everyone has a story to tell, and if you ask and lend an ear, the subject will tell you theirs. My friend was born in the United States, but her cultural lineage is quite diverse. She has prominent Nigerian heritage, but she can also trace her roots to several African regions, and some European. I realized how blended we are as people as she shared the vast locations of her ancestry with me.

The day was ideal. It was hot and humid, but the sky was overcast. This created a nice, soft, diffused light. I was initially undecided as to whether I wanted to incorporate light into my shots or rely on the afternoon sun's soft, diffused glow as the primary light source. In the end, I opted for natural ambient light. As we walked around, I looked for areas that complemented my friend's personality and the outfit she wore.

Her outfit was perfect—a nice medium yellow with a slight vibrance, but

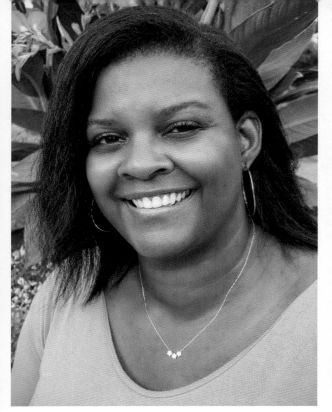
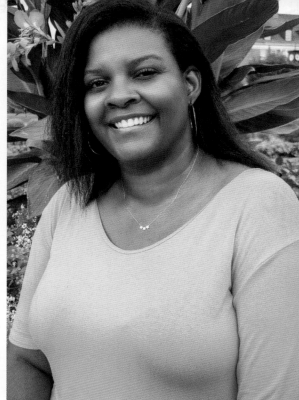

left. Image 10.9.
right. Image 10.10.

not overbearing. Color choice can be an issue. It can clash with a scene or, more critically, it could conflict with the person's skin tone or hair color. In these images, the yellow accentuates the subject's features. It adds to the radiant glow that is part of her naturally stunning elegance. It complements and highlights her features.

I shifted the focus point toward the center portion of the university's front lawn. It features a lush garden filled with an array of plants and flowers, each of which complemented my friend's appearance. It took a few tries,

but ultimately, we found a location where the flowers were not overbearing, and some of the central portions of the campus could be seen making their way into the background. See images 10.9 and 10.10.

Something to always keep in mind is where the light is coming from when using ambient light. It's no different than using artificial light. The natural light source is the key light, it should be located at a 45-degree angle to your subject.

We ventured across campus to one of the outdoor seating areas. School was

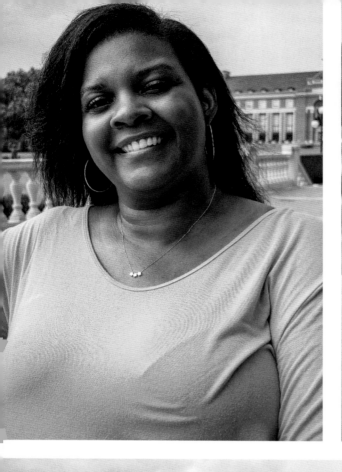
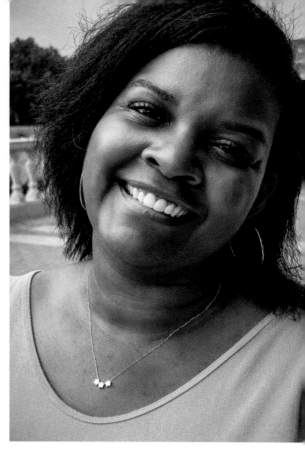
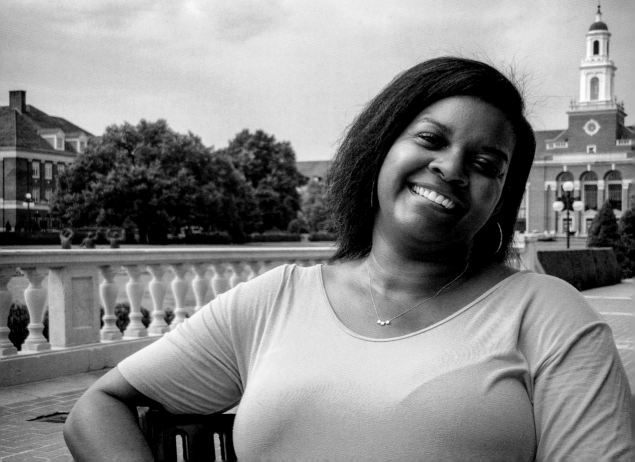

previous page, top left. **Image 10.11.**
previous page, top right. **Image 10.12.**
previous page, bottom. **Image 10.13.**

not in session, so it was easy to find a location without the worry of people or other distractions. More of the campus was present in the background. Our new location was a lateral move from our last, so the sun was in the same position. However, some of the clouds began to break and a few darkened. This provided a nice bluish-gray color to the sky. Once I found a location I was satisfied with, I had my friend remain stationary while I moved around to take photos from different angles and distances. See images 10.11–10.13.

One challenge was how to get her eyes sharp and noticeable. As I was using natural lighting, I had little control over how the light illuminated her face and eyes. This is the reality of using ambient light rather than flash, and it was a trade-off I was keenly aware of.

I like to have fun and experiment when I am shooting outside. Next to the outdoor dining area, there is a set

> **"As I was using natural lighting, I had little control over how the light illuminated her face and eyes."**

of stairs that is often used by photographers for various photo shoots. This was an opportunity to ask my friend to sit on the stairs and relax (image 10.14). I explained that my intention was to use a wide-angle lens to distort the image and yield a fun-looking photo.

The final two images were the most important, as I knew what look I was going for. I compiled a few sample images of lying poses for my friend to review to make sure she would be comfortable trying them.

We made our way to the front lawn of the university. I asked her to lie down in a similar position to what I had previously shown her. I had her make

below. **Image 10.14.**

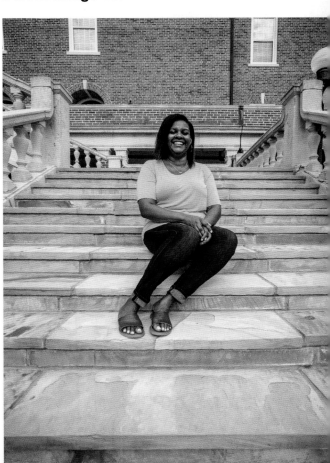

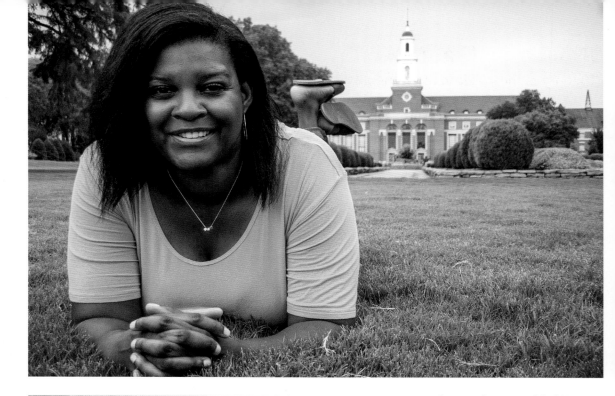

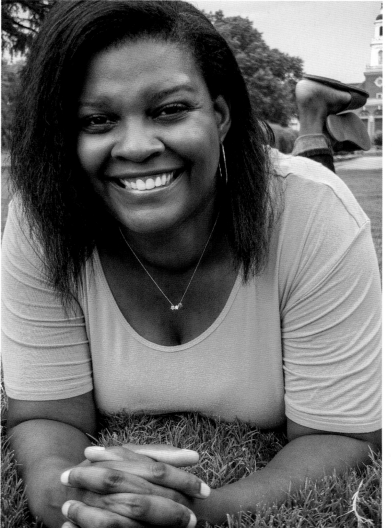

above. Image 10.15.
left. Image 10.16.

slight adjustments until she found a comfortable position. The result? A balanced and layered photo. Your eyes seamlessly transition from one object in the frame to the next. However, the attention is never taken away from the main subject. In images 10.15 and 10.16, notice the relationships between her body, feet, the rows of bushes, the walkway, and the library behind her.

Rooted in Tradition

"Beauty is the wisdom of women."
—Chinese proverb

I have always been enamored with culture—especially Asian cultures. My friend has Chinese and Taiwanese heritage. She embraces traditional values, respect for elders, and removing shoes when inside the home. She has a fun personality to boot. She is often one of the most upbeat people I have encountered.

I wanted to take all of her photos outside at one of the local lakes. I had some ideas for a few locations. However, these were busy public areas, and we discovered that other photographers had already taken those locations. When we arrived, I noticed a flowerbed atop a small hill. The grass was uniform and soft, and my concept for the photo became clear. I asked her if she would be comfortable lying down on the ground with her arms underneath her. I moved around, taking photos from several angles until I found one with a smile that could not have been more perfect. See image 10.17.

"There is the possibility that reflections from the light source will appear in a subject's glasses."

I wanted a portrait that was somewhat traditional. We moved over to a tree, and I had her try a few poses. I wanted to take photos that highlighted her smile and facial features. One of the most significant challenges was her glasses. There is the possibility that reflections from the light source will appear in a subject's glasses. You may also notice other unwanted reflections. I used the Profoto C1 for this shoot, and it can cast harsh light if it is not in the right position. There are two solutions in this situation. The first is to move the subject or the light to a slightly different angle to see if it reduces glare.

below. **Image 10.17.**

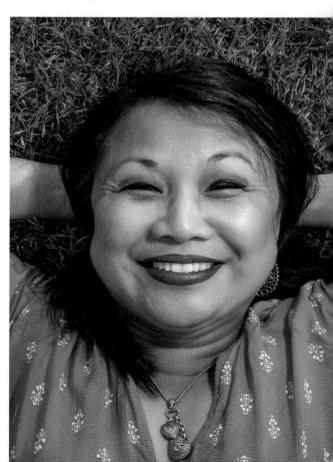

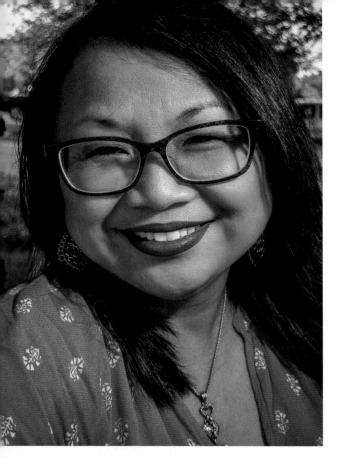

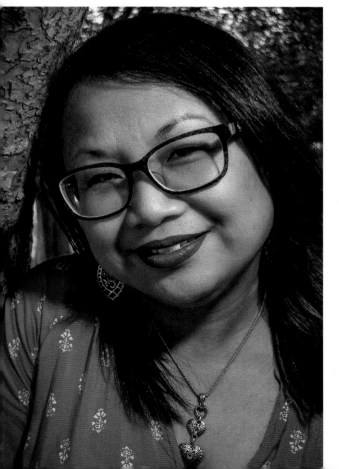

top. **Image 10.18.**
bottom. **Image 10.19.**

Alternatively, you can ask the subject to remove their glasses if they are comfortable doing so. In this case, having my subject turn her head a few fractions of an inch remedied the problem. See images 10.18 and 10.19.

Every time I see this woman she is smiling. No matter what scene I placed her in, I knew I could count on a big smile. We changed locations and found yet another tree, but this time, we had of part of a lake, some boats, and even a lighthouse in the background.

When you compose your images, be mindful of the interplay between your subject and any objects in the background. Ask yourself if they complement the subject or are a distraction. If they are a distraction, can they be diminished?

Sometimes the background can be overwhelming. Moving the subject a few inches will often solve the problem, but choosing a different location may be necessary.

There is a lighthouse in the background in two of the images. In both

"Be mindful of the interplay between your subject any objects in the background."

cases, the lighthouse is to the left (subject's right). However, in image 10.20, it is just barely to the left of my friend. Is this a distraction? What about the island protruding out? In this instance, no. We are aware of the background objects in image 10.21. They are not too distracting, however, because they are blurred and in the distance. When background objects are in focus and close enough to your subject, they can read as new appendages in the portrait.

In each of these scenes, the sun was very bright and directly behind the subject. Therefore, it was important to remember to use some type of light source to help fill in the shadows on the subject. As you can see in images 10.22 and 10.23 (following page), the result was a pair of incredible photos. The subject was well lit, and there is even a little bit of lens flare to spice things up.

I wanted something a little more subtle for the final image. We made our

left. Image 10.20.
right. Image 10.21.

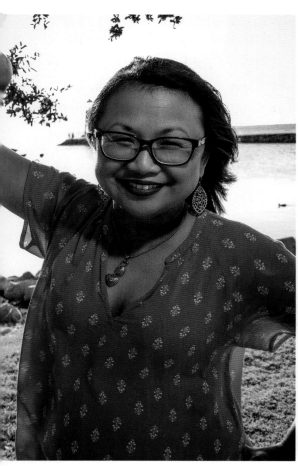 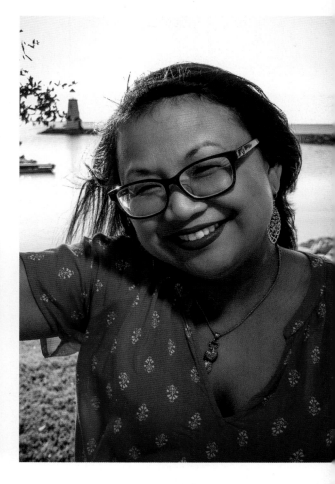

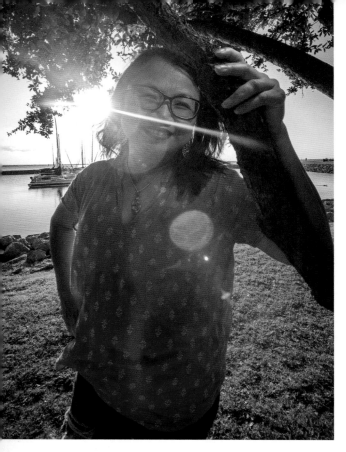

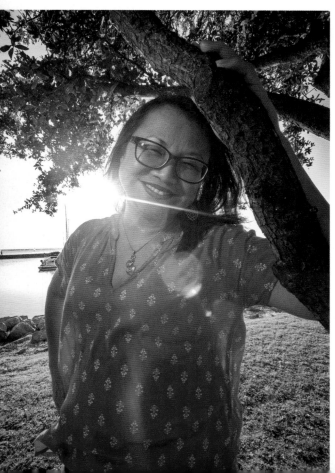

left. Image 10.22.
right. Image 10.23.
following page. Image 10.24.

way to the end of the island previous-
ly behind us, by the water, and just in
front of the lighthouse.

For this shot (image 10.24), I asked
her to give me a subtle smile, and I
asked if she would be comfortable
removing her glasses. The shadow
of the lighthouse acted as a diffuser.
Off-camera lighting was used to open
up the shadows. With my subject's
back to the water and a slight smile,
the final image yielded a beautiful
portrait she would be proud to dis-
play. The sun glistened lightly on her
hair. Boats can be observed off in the
distance. Each of her uniquely identi-
fying traits is highlighted.

"The shadow of the lighthouse acted as a diffuser."

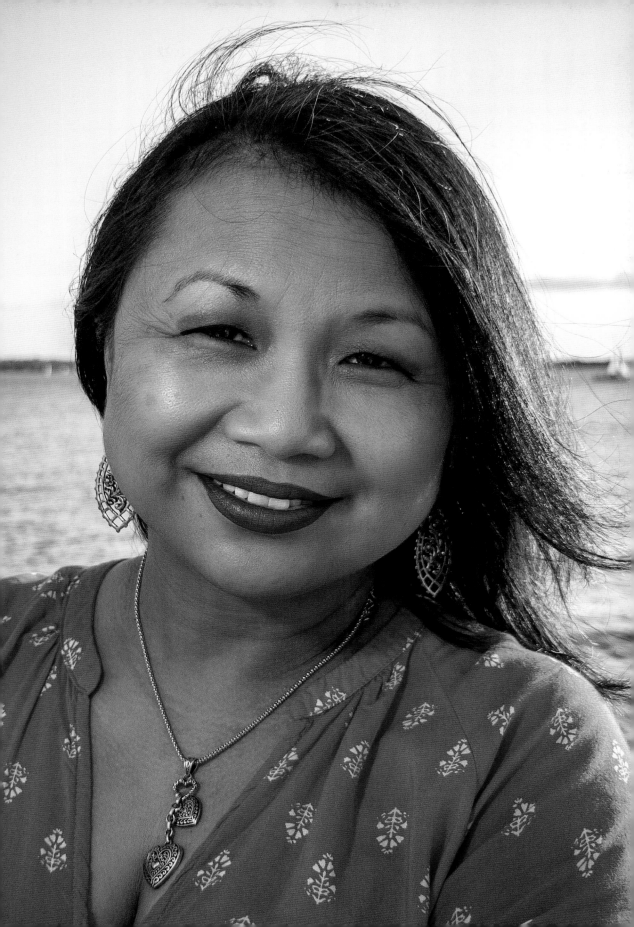

11. Guys

Guys are often laid back, and at times it can be difficult to pose them or coax information from them that might help you better understand the person you want to photograph. More often than not when I query male clients, I get standard responses like, "I don't care. Just take the shot." That said, I am also asked, "Does this look okay?" Many guys, myself included, are somewhat self-conscious. Therefore, it is just as important to ensure you photograph what is unique about that person as it is to make sure they are comfortable with the process.

One of the things I seek when photographing guys is definition. I yearn to create photos with contrasting tones and to emphasize prominent traits such as wrinkles, lines, arms, eyes, and tattoos. In fact, I prefer to photograph older and more defined faces.

When photographing men, pay attention to the scene and the type of clothing they wear. I find that capturing them in the midst of one of their favorite activities often works just as well as placing them in front of a backdrop. In either event, the end goal is to get them comfortable enough to trust you and have fun with the shoot.

For these shots, a combination of the following equipment and techniques were used:

- iPhone XS
- iPhone stock lens
- Moment 58mm lens
- Light stands
- Tric flash trigger
- Speedlights
- 9-inch portable softbox
- Westcott X-Drop and conventional backdrop system
- Lume Cube 2.0
- ProCamera app
- Profoto camera app (for use with the Profoto C1 Plus Light), Camera Raw format, and automatic ISO and shutter speed adjustments.
- TricCam app (for use with the Tric flash trigger and speedlights); Camera Raw format, and manual light ISO and shutter speed adjustments
- Adobe Lightroom mobile photo editor

- At-home editing: Adobe Lightroom
 CC, Adobe Lightroom, and Photoshop

Light Placement & Camera Settings

Off-camera light was used on all shots except when noted. Off-camera lighting was used when outside to properly expose each subject when they were in shadows or in scenes with strong background lighting. ProCamera and Profoto apps were set to use auto exposure. When used, the Profoto C1 Pro lighting unit was set to produce maximum output, and the camera exposure was adjusted via an exposure value (EV) correction of between −1.7 and −0.8.

The TricCam app requires manual adjustments for the iPhone XS. Manual ISO settings were between 25 and 200, and shutter speeds were between $1/30$ and $1/45$ second. In some cases, Tric shutter speeds were set as high as $1/125$ second; however, Tric does not offer high-speed sync options, and there are occasions when the flash and shutter do not match.

Shoot What Looks Good & Suits Them

One of my male subjects received a double dose of abuse. Not only did he

top. Image 11.1.

bottom. Image 11.2.

top. Image 11.3.
bottom. Image 11.4.

very easy to photograph because he is so laid back that you can have a conversation about anything while continuing to shoot.

I wanted something fairly traditional for the first few photos. So we worked around the water and gazebo used earlier. To keep things simple, I asked him to stand with his arms crossed, a nice smile, and lean up against one of the posts under the gazebo awning. The sun was setting, and there were equal amounts of shade under the pavilion at all ends. Off-camera light was used to balance the shadows. The toughest task was finding a post for the subject to lean on that would yield an appealing background. See images 11.1 and 11.2.

Because the subject is also a photographer, I wanted to take a few photos that highlighted his passion. Luckily, he brought his camera. I followed him around and took photos as if he was out scouting shooting locations or taking a few wildlife photos. The images I took were what I was looking for. They seemed to allude to a NatGeo photographer on assignment, and the background scenery added to the authenticity of the photo. See images 11.3 and 11.4.

participate in a couple's session with his wife, but he was also my subject for some individual portraits. He has a great personality and is easy to get along with—the type of subject who is

The Vertically Blessed

I wanted to photograph my friend's husband, who helped me out with some earlier family photo shoots. He is tall and has a slender build, yet his face and arms are very masculine and well defined. I wanted to highlight these traits, and I knew they would yield an incredible look if exploited. I decided to keep things simple and photograph him indoors, in front of a backdrop.

Once we got started, it became apparent that his height prevented him from being isolated in the frame. Much of the time, the ceiling or the top of the backdrop was noticeable. So, this was an opportunity to experiment and do something different from what was planned.

We grabbed a chair from the kitchen and got to work. I had him turn the chair around and place his arms over the top. Normally, a high-backed chair would not be ideal for this situation, but because of this subject's height, it was perfect. A mid- or low-backed chair is best for most clients.

I experimented with a couple of different post-processing techniques

> ***"A mid- or low-backed chair is ideal for most clients."***

left. **Image 11.5.**
right. **Image 11.6.**

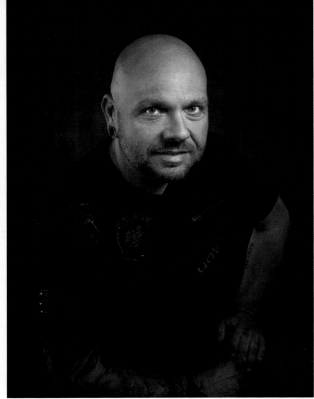

left. Image 11.7.

right. Image 11.8.

following page. Image 11.9.

(images 11.5 and 11.6) to see which version of the photo had more appeal for him and his wife.

This Is Me

Sometimes we go into a shoot with an idea, but that idea is changed for one reason or another. Most of the time, I can take photos that genuinely express who my client is. Other times, it is more of a challenge. In this case, I knew exactly what I wanted to do with my friend. When I arrived, he was focused on what he could wear that was representative of him. While there may have been concern that I was looking for something entirely different, he was, in fact, moving in the direction I was hoping for.

Pay attention to any concerns your subject has. If someone tells you, "This is me," be sure to listen, no matter how small their concern.

"If someone tells you, 'This is me,' be sure to listen, no matter how small their concern."

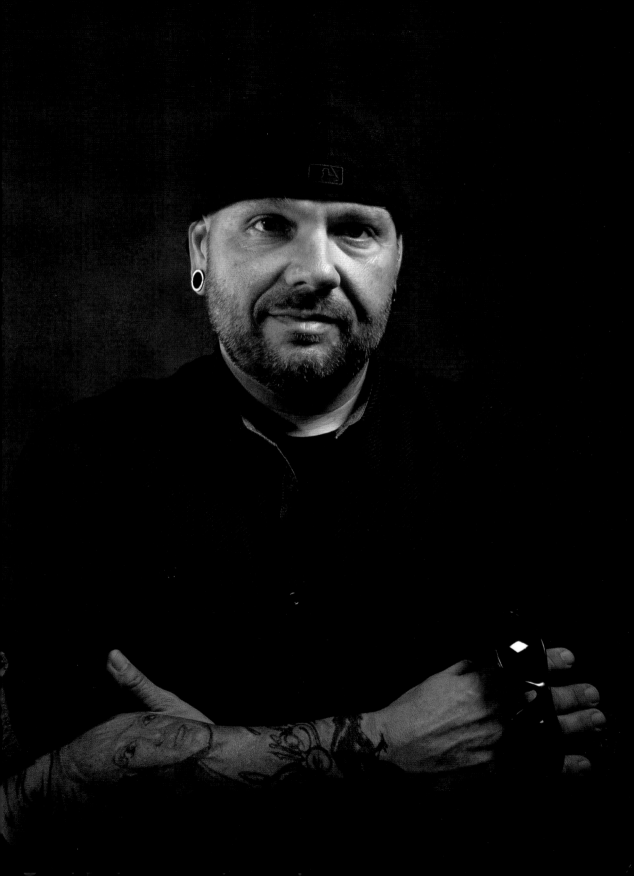

I captured several shots with a variety of poses. The brown background was perfect for this subject. It not only suited his skin tone and features, but it also complemented his style. The photos came out better than I had envisioned. See images 11.7–11.9.

Don't be afraid to experiment and try different things. I had my friend change what he was wearing. He mentioned that he usually wears a hat and typically has his sunglasses with him. These accessories are a part of his identity, and they help communicate who he is.

As we were shooting, he commented on his tattoos and asked if it would be possible to make sure they were noticeable. As you look at the photos, pay attention to the position of his tattooed arm. The arm is never covered up and is always out front. It complements each scene and is used to draw focus.

For the final shot, image 11.10, I asked my friend to stand at about a 45-degree angle to the camera, put his head down, and motion as if he were putting his hat on. This scene took a bit of planning. The key light was directly behind the subject and illuminated his face and neck. This was a challenge because he was wearing a hat, and shadows were cast across his face. A fill light was used to open those shadows and highlight just the tattoo on his arm.

"Don't be afraid to experiment and try different things."

following page. Image 11.10.

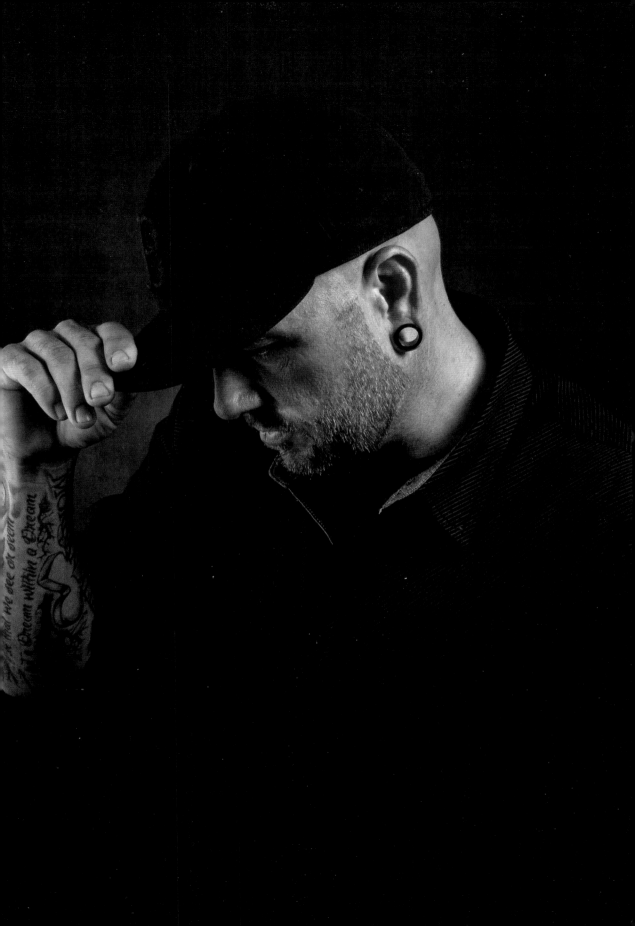

12. The Senior Portrait

Life continually changes, and the occasions for taking a photograph are no different. When I was younger, a senior photo was something you took that stood out in the yearbook. All other grades had black & white thumbnail images. But not you. Now you were a senior, and that little thumbnail was in color. It was in the front pages of the yearbook for all to see. It separated you from everyone else and identified your place in the high school food chain.

Several years ago, I found that my vision of the senior photo had changed. Those coveted thumbnail images, while still used, are not what set you apart. Now the trend was to hire a photographer and take photos that gave the appearance your kid was trying to break into their modeling career. The cost of these photos could run upwards of $1,000 U.S.!

"Informal settings and casual attire often work best, unless the teen wants something more formal."

Senior portraits are a series of photos that portray your beloved child as an adult. They range in style from very formal photos made in exotic locales to very simplistic and laid-back images.

I discovered with my teenage daughter that the senior photo is a documentary of who the teen has become. The outfit and scene, though nice, are not the most important characteristics. What's important is showing the subject's identity. As a photographer, I learned that informal settings and casual attire often work best, unless the teen wants something more formal.

For these shots, a combination of the following equipment and techniques were used:

- iPhone XS
- iPhone stock lens
- Moment 58mm lens and 18mm lens attachments
- Light stands
- Tric flash trigger
- Speedlights
- 9-inch portable softbox
- Lume Cube 2.0

- ProCamera app
- Profoto camera app (for use with the Profoto C1 Plus light), Camera Raw format, and automatic ISO and shutter speed adjustments
- TricCam App (for use with the Tric flash trigger and speedlights); Camera Raw format, and manual light ISO and shutter speed adjustments
- Adobe Lightroom mobile photo editor
- At-home editing: Adobe Lightroom CC, Adobe Lightroom, and Photoshop

Light Placement & Camera Settings

Off-camera light was used on all shots except when noted. Off-camera lighting was used when outside to properly expose each subject when they were in shadows or in scenes with strong background lighting. ProCamera and Profoto apps were set to use auto exposure. When used, the Profoto C1 Pro lighting unit was set to produce maximum output, and the camera exposure was adjusted via an exposure value (EV) correction of between −1.7 and −0.8.

The TricCam app requires manual adjustments for the iPhone XS. Manual ISO settings were between 25 and 200, and shutter speeds were between $1/30$ and $1/45$ second. In some cases, Tric shutter speeds were set as high as $1/125$ second; however, Tric does not offer high-speed sync options, and there are occasions when the flash and shutter do not match.

Is That Really What You are Wearing?

I asked that question as my daughter got into the car. I think she sneered at me. We were setting out to go take a few photos that would kick off her senior year. She saw no issues with what she wore and even told me that it was a nice shirt. It is what kids wear these days. I found myself quickly scrolling through Pinterest, looking over senior photos, and making wardrobe comparisons. However, she was right. Had I done more research, I would have discovered that teen outfits for their senior photos were far more casual than I suspected. While some teens were dressed to the nines, there were plenty of examples of seniors wearing jeans, tennis shoes, and maybe a nice shirt. I was quickly reminded it was about them and their style, not mine.

We set off to find a few locations in the local downtown area. My daughter asked to find something abandoned for one of her portraits, and while we did not find an abandoned building, I opted for the shell of an old and widely unused park. Even though senior sessions are supposed to be about identity, I tend

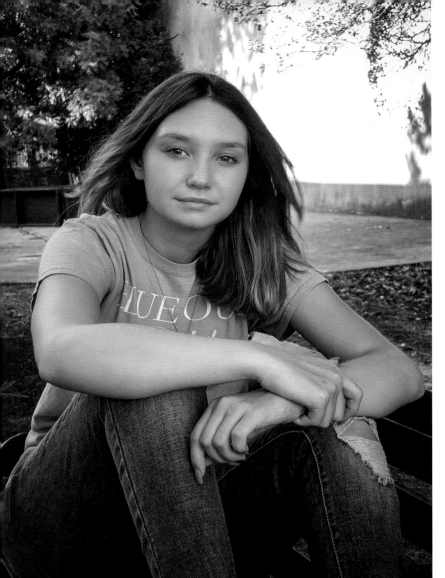

prepared to offer some guidance.

The first shot, image 12.1, was simple, and I already envisioned something associated with a park bench. I had my daughter sit down and try various poses. Eventually, I found one that I liked and which worked with her style. She had the perfect smile, and the wind was blowing just right. While I would have been happier with a slightly blurred background, the end product worked. The background was not distracting, and it added a nice element to the scene. Everything was well balanced.

Other shots were up in the air regarding what we would try. As I scouted for our next location, I noticed my daughter playing between a set of trees out of the corner of my eye. The trees were close together, and I asked her to hold the trees on either side. It worked, but something was off (image 12.2).

to think of them as mini modeling sessions. Often, this is the first time teens have professional photos taken. They may not know what to expect, so be

> ## *"They may not know what to expect, so be prepared to offer some guidance."*

I asked her to lightly hang onto the trunks and lean forward (image 12.3). This produced a look that caught my eye, and I took a few photos. She, however, felt it was ridiculous. Eventually, I had her move to one of the larger trees. I was not looking for anything fancy and opted for a somewhat conventional pose. See image 12.4.

We found the remnants of a wall toward the back of the park. It appeared to be what was left of a now-forgotten building, and most likely, what would have been the back receiving area. Several barred window openings remained.

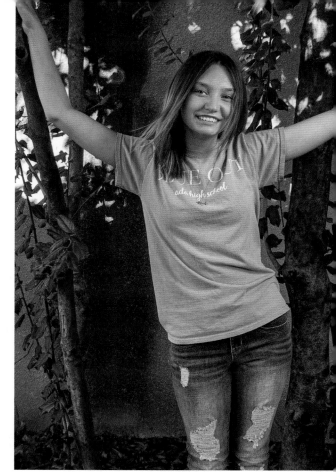

top right. Image 12.2.
bottom left. Image 12.3.
bottom right. Image 12.4.

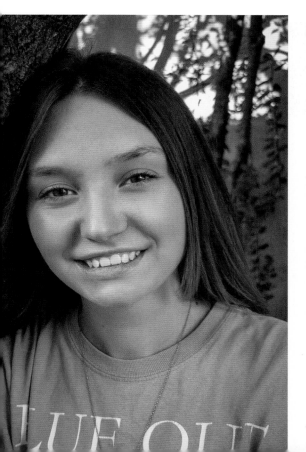

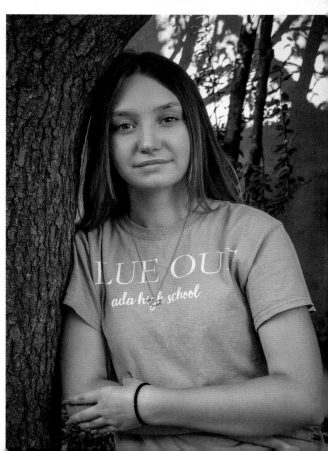

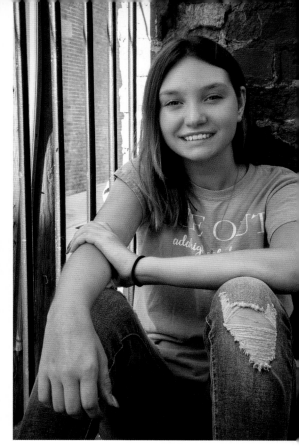

left. Image 12.5.
right. Image 12.6.

After some inspecting, we found an opening that was not too difficult for her to climb in. The alley behind the location added to the interesting choice of location.

While the opening was perfect, it took some experimenting to ensure that nothing would be a distraction in the

> **"Play with your angles until you find one that works for you and complements your subject."**

background. The other challenge for me was directly related to the scene. Notice each of the lines in images 12.5–12.7. There are lines in the brick. There are also lines from the window bars that run perpendicular to the brick's more prominent lines. Lines and geometric shapes can be a distraction. You may not initially realize what the distraction is, but as you examine the image, your eye can detect that something is not quite right. Play with your angles until you find one that works for you and complements your subject.

I noticed some exposed brick and piping protruding behind one of the building's stucco facades as we were leaving. This warranted an unplanned shot, and one that was more in line with the abandoned theme we sought. Notice the difference in images 12.8 and 12.9 (following page). One portrait is from the waist up. The other is a full-length shot. Look at what is taking place in each scene. Notice how the subject fills the frame. While I prefer to take close-up photos, I also like capturing ½, ¾, and full-length pictures if the setting warrants. In the case of the full-length image, the subject completely fits the top and bottom of the frame with little room to spare. However, she is centered and complemented on either side by the elements. This adds a new dynamic to the scene. Would the effect be the same if the subject were in the same position, but the wall was featureless on either side?

The final image was planned to a degree. I knew I wanted to use a wide-angle lens to create a dynamic photo of my daughter in the middle of the street, where one could see some of the downtown buildings. Because of the time of day, I also knew I would get a silhouetted image and possibly some

below. **Image 12.7.**

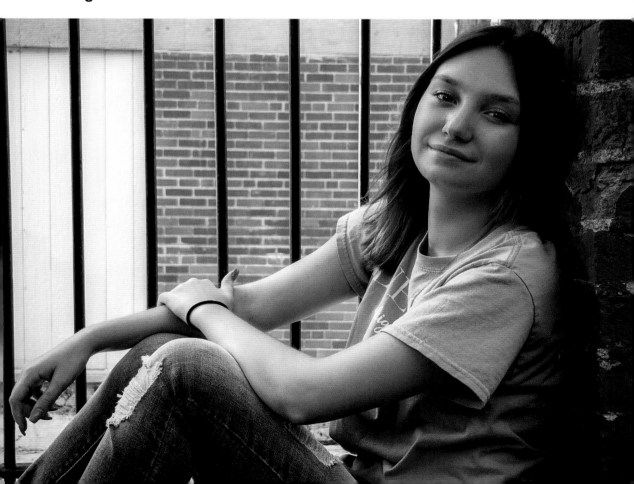

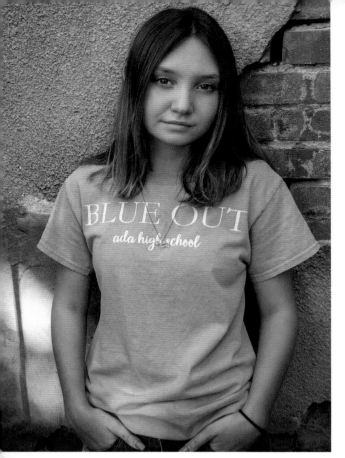

vehicle traffic. In this instance, I did not use any supplemental lighting. I only wanted to expose for the background. The sun's location was an added bonus. We waited just a bit longer for the sun to set a few more inches. The result was an incredible photo of my daughter with her arm, apparently, wrapped around the sun (image 12.10).

"I only wanted to expose for the background. The sun's location was an added bonus."

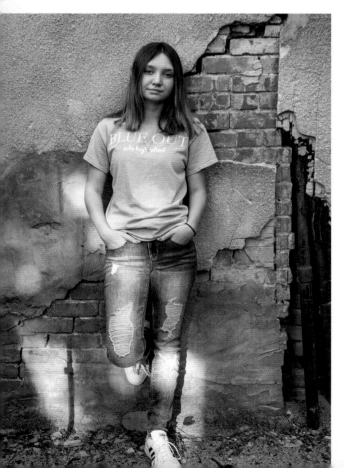

top. Image 12.8.
bottom. Image 12.9.
following page. Image 12.10.

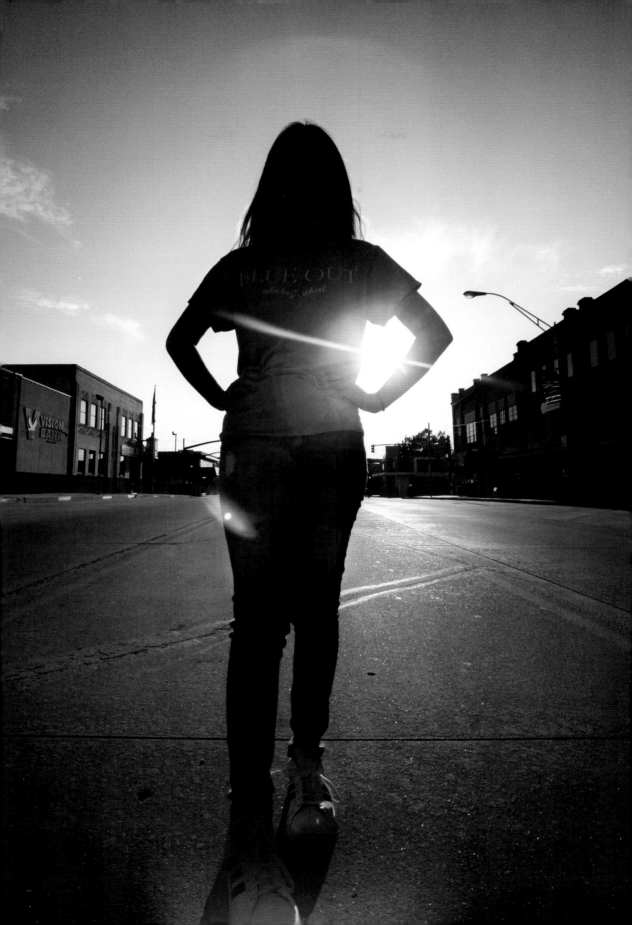

13. Black & White

I love black & white (monochrome) photography. It is not a genre people often consider when taking portrait, but it certainly has its place. Black & white will not work in all situations. So careful consideration is needed when deciding whether to convert a photo from color to monochrome. With that being said, some people absolutely love black & white photography regardless of the final look. Above all else, black & white photography is an art form, and only you can decide which of your photos will benefit. At the end of the day, the only person's opinion that matters is yours.

Sometimes, converting a photo to black & white can "save" an image. I am guilty of doing this, as are many other photographers. I have used it to fix a photo that is a little too noisy. I certainly have used it when a photo came out too blurry. I have used it when the exposure wasn't just right, and in other instances when I wasn't satisfied with the final color product. However, there are times when converting an image to black & white can make some mistakes more noticeable.

At times, I may take a photo with the intent of converting it to black & white. Other times, I may convert it in post-processing to see if the photograph looks better. Yet, outside of commercial photography, we rarely see the average person convert their photos. This could be because they are not adventurous enough, they never gave it any consideration, or they don't know how to. I have had people tell me before they are simply afraid to experiment.

For these shots, a combination of the following equipment and techniques were used:

- iPhone XS
- Moment 58mm lens attachment
- Light stands
- Tric flash trigger
- Speedlights

> *"Careful consideration is needed when deciding whether to convert a photo from color to monochrome."*

- 9-inch portable softbox
- Godox 47-inch octagon softbox
- Westcott X-Drop and conventional backdrop system
- Lume Cube 2.0
- ProCamera app
- Profoto camera app (for use with the Profoto C1 Plus Light), Camera Raw format, and automatic ISO and shutter speed adjustments.
- TricCam App (for use with the Tric flash trigger and speedlights); Camera Raw format, and manual light ISO and shutter speed adjustments
- Adobe Lightroom mobile photo editor
- At-home editing: Adobe Lightroom CC, Adobe Lightroom, and Photoshop

Light Placement & Camera Settings

Off-camera light was used on all shots except when noted. Off-camera lighting was used when outdoors to properly expose each subject when they were in shadows or in scenes with strong background lighting. ProCamera and Profoto apps were set to use auto exposure. When used, the Profoto C1 Pro lighting unit was set to produce maximum output, and the camera exposure was adjusted via an exposure value (EV) correction of between −1.7 and −0.8.

The TricCam app requires manual adjustments for the iPhone XS.

Manual ISO settings were between 25 and 200, and shutter speeds were between $^1/_{30}$ and $^1/_{45}$ second. In some cases, Tric shutter speeds were set as high as $^1/_{125}$ second; however, Tric does not offer high-speed sync options, and there are occasions when the flash and shutter do not match.

Make It Interesting

Almost every portrait session I do, I go in with the idea that I will take at least one black & white image. I am a fine-art photographer, and I love the ability to be artistic and creative. I tend to use one of four lighting styles, but I often experiment, as well. My key light is often set up for either Rembrandt, loop, split, or butterfly lighting. I may or may not use a fill light, and the same is true of hair lighting.

I knew I wanted a black & white image of this couple. I also knew that I wanted a particular pose because it fit the way I see them together. I knew I would produce a photograph they were not accustomed to seeing (image 13.1).

I asked him to stand behind her and look down lovingly while she looked at the camera. I also asked her to reach up and hold one of his hands as it rested across her shoulder. We waited until the end of our family photo session because I wanted to capture the exhaustion in

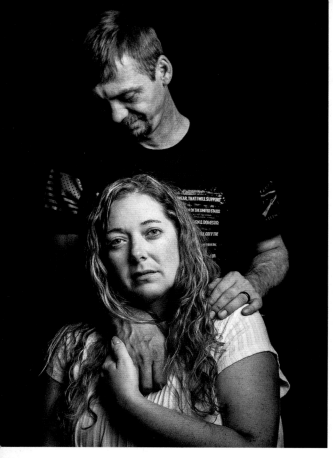

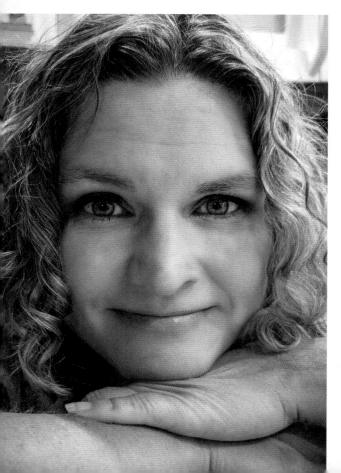

top. Image 13.1.
bottom. Image 13.2.
following page. Image 13.3.

their expressions. It is something many parents can relate to.

I finished this image of my friend in black & white for a different purpose. Being artistic was not in the cards. Nonetheless, I wanted a slightly different look for her. There is an even tonal balance throughout image 13.2. The black & white also helped to highlight her eyes.

I had plans for my friend who helped me with a country-themed shoot. I knew I wanted at least one of her indoor portraits to be black & white. However, I did not want something traditional for her. I wanted something artistic. Something that was a little out of her element. I had her pose in a way that extenuated her frame, hair, and facial features. I used a gray backdrop that worked well with the color of her outfit and skin tone. See image 13.3.

As a photographer, you must be aware that you are creating a situation in which your subject may be uncomfortable. You are asking them to do

"Be aware that you are creating a situation in which your subject may be uncomfortable."

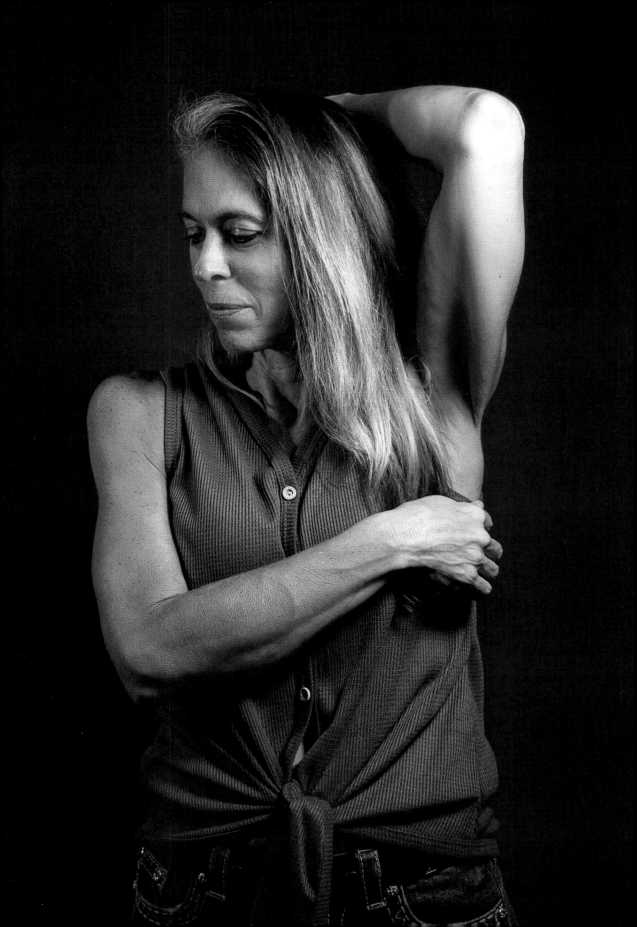

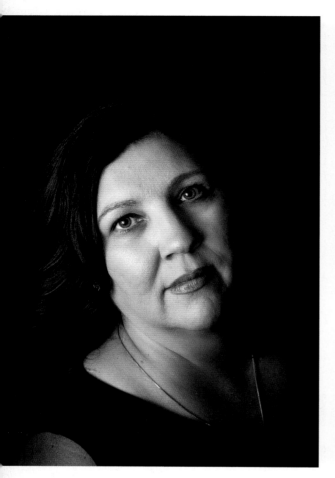 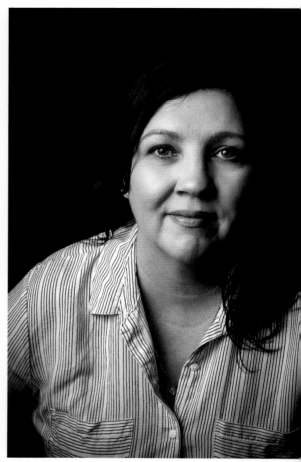

left. Image 13.4.
right. image 13.5.

something they are not accustomed to. They will be placing a great deal of trust in you.

My Native American friend has several features that I knew would make for a great black & white portrait. The color of her skin, combined with her dark hair, is ideal with an all-black background. Her eyes are stunning, and they are what one is drawn to in each of her images. We played around with a few angles and outfit changes. The background remained the same. She wore all black in the first photo, which helped with the transition between light and darkness. This created a scene of deep, rich, contrasty tones that are pleasing to the eye. See image 13.4.

"Light-colored clothing can also reflect light."

The change of clothing in image 13.5 created a little juxtaposition. The transition from the subject's hair to the background is blended, as in the previous photo. However, now there are distinct lines around her shoulders due to the lighter color of her outfit. The edges are more prominent and recognizable. Light-colored clothing can also reflect light. This can both fill and darken shadows, and it is something to be aware of. In the end, her features are well defined, her skin is soft, and her eyes are stunning.

top right. Image 13.6.
bottom left. Image 13.7.
bottom right. Image 13.8.

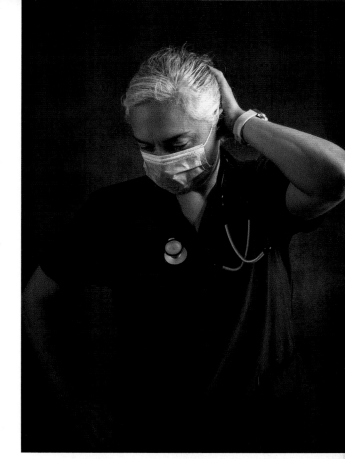

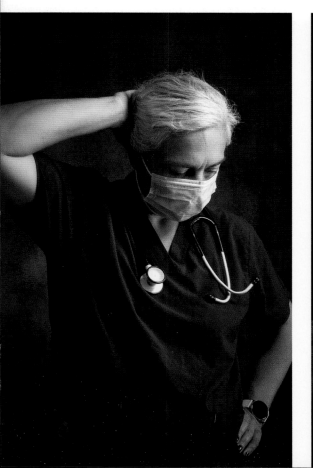

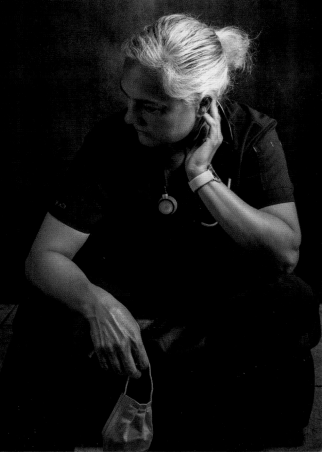

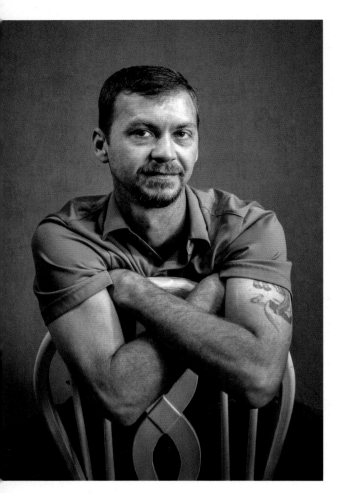

left. **Image 13.9.**
following page. **Image 13.10.**

I wanted to take a few photos in black & white of my nurse friend. The act of converting her images to black & white dramatically changed the fundamental nature and context of the photos. See images 13.6–13.8.

Black & white can be a powerful tool that injects more emotion into a given scene. There is often a noticeable difference in the message that is being conveyed when comparing a black & white photo to a colorized version of the same image. The background will have just as much of a dramatic effect on the final portrait, as will the lighting style.

I knew I wanted one of the images of my male subject sitting backward on the chair to be in black & white (image 13.9). However, as we were wrapping up shooting, he commented that he wanted a shot that made him look like Leo (DiCaprio). So, why not get creative and try it? I knew this would be an opportune moment for a contrasty black & white image of him. I had him turn sideways in the chair, and I placed a key light directly behind his head. I then placed a small fill light in front of him. The goal was to illuminate his face from behind, which creates a distinct array of shadows. I also had him try a few hand positions. Eventually, he found one he was comfortable with. See image 13.10.

I wanted a photo of my son that would be in black & white. He begrudgingly sat through my experimentation. Nonetheless, image 13.11 is one

"Black & white can be a powerful tool that injects more emotion into a given scene."

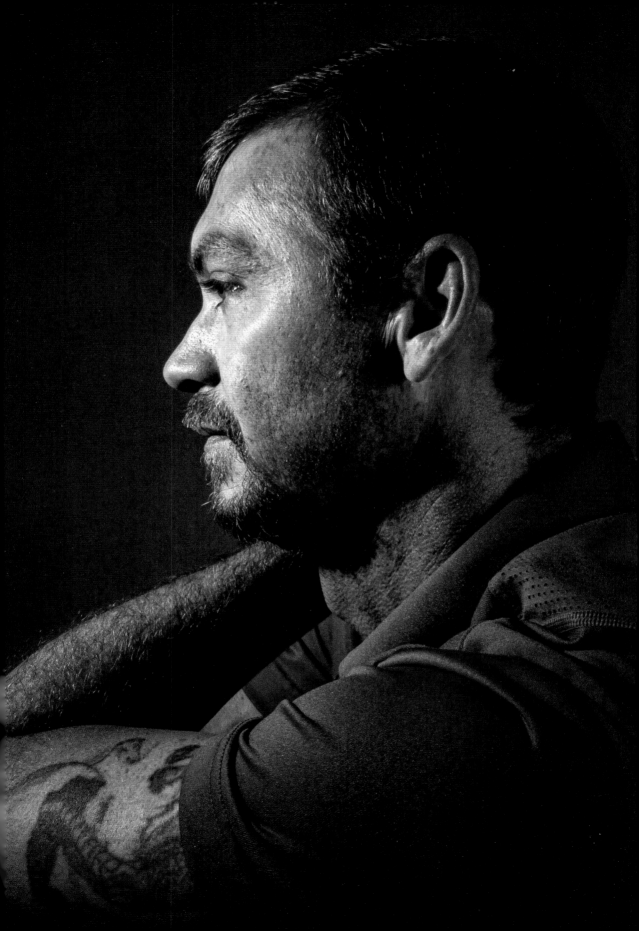

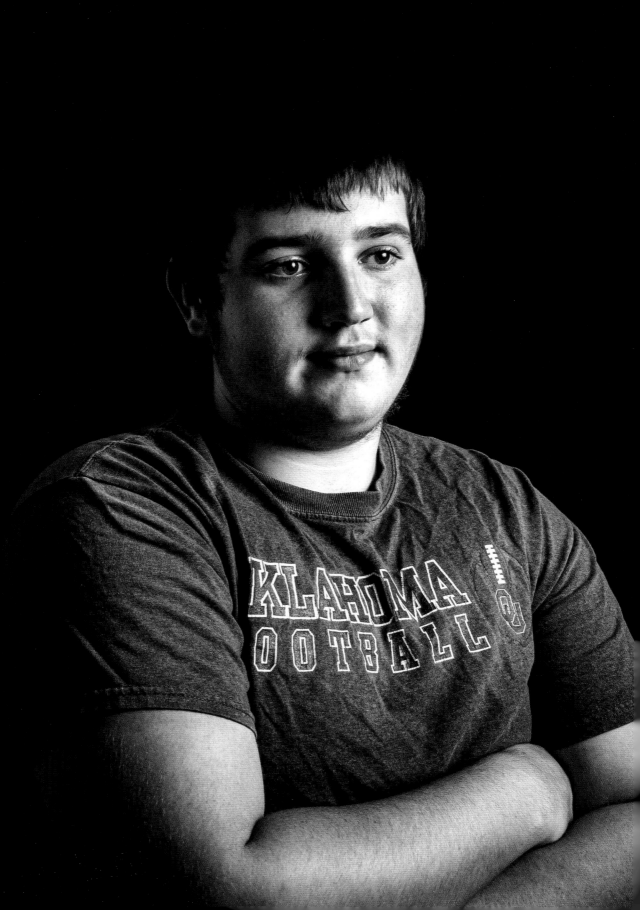

previous page. **Image 13.11.**

I can add to my children's collection that documents the years of torture and my never-ending obsession with forcing my kids to pose for photos. After all, that is what parents do best.

Light Is Critical

Light is a critical ingredient in great black & white photos. While one does not have to be an expert in light, understanding its importance and effect on the final image is critical. Great monochromatic images contain near-palpable textures and creamy shades of black & white. The tones can be, and often are, more dramatic than they are in the colorized version. This can bring out details that often go unnoticed. The transition from light to dark and the difference between harsh and soft shadows can dramatically change the entire appearance and mood of a scene. Experiment with light unless you have a specific setup in mind. When you do, you may discover a different look than you anticipated.

"Experiment with light unless you have a specific setup in mind."

14. The Selfie

We have all taken a selfie for one reason or another. I often refer to them as "the dreaded selfie" because I, like most photographers, prefer to be behind the camera, rather than in front of it. However, with a little planning, you can end up with a nice selfie that you are comfortable sharing. The reason for taking a selfie can be expansive and includes taking a spur-of-the-moment image, to wanting something a bit more formal or professional.

Some people are comfortable taking pictures of themselves. They may even do it several times a day. While the reason for the selfie varies from one person to the next, the concept is the same: showing off you. Other people, like me, only take a selfie when they must. On this day, I decided to make myself the guinea pig.

When you take selfies, be conscious of your surroundings. The bathroom

"With a little planning, you can end up with a nice selfie that you are comfortable sharing."

selfie, while convenient, is probably not the best location every time. There are also some challenges to taking a selfie. Often, people handhold their camera out at arm's length to take the picture using their phone's front-facing camera. While its popularity seems to have faded, the selfie stick was a trendy alternative to handholding the camera. Unfortunately, using a selfie stick can make an image look a little bizarre, and many places, such as amusement parks, now ban the devices.

When taking a selfie, consider using a tripod in conjunction with your iPhone's timer so you can use your rear-facing camera, prevent camera shake, and add distance between you and the lens. You can also purchase a Bluetooth remote shutter trigger. These low-cost devices are often under $20 U.S.; however, some cost much more. You can easily conceal the trigger in your hand with some creative posing. You can also brace the iPhone against an object with some creative experimentation if a tripod is not available. For improved results, you can use

backdrops and play with lighting. This is your opportunity to be creative.

For these shots, a combination of the following equipment and techniques were used:

- iPhone XS
- Moment 58mm lens attachment
- Moment lens adapter
- Light stands
- Tric flash trigger
- Speedlights
- 9-inch portable softbox
- Westcott X-Drop and conventional backdrop system
- Lume Cube 2.0
- ProCamera app
- Profoto Camera app (for use with the Profoto C1 Plus light), Camera Raw format, and automatic ISO and shutter speed adjustments
- TricCam app (for use with the Tric flash trigger and speedlights); Camera Raw format, and manual light ISO and shutter speed adjustments
- Adobe Lightroom mobile photo editor
- At-home editing: Adobe Lightroom CC, Adobe Lightroom, and Photoshop

Light Placement & Camera Settings

Off-camera light was used on all shots except when noted. Off-camera lighting was used when outdoors to properly expose each subject when they were in shadows or in scenes with strong background lighting. ProCamera and Profoto apps were set to use auto exposure. When used, the Profoto C1 Pro lighting unit was set to produce maximum output, and the camera exposure was adjusted via an exposure value (EV) correction of between −1.7 and −0.8.

The TricCam app requires manual adjustments for the iPhone XS. Manual ISO settings were between 25 and 200, and shutter speeds were between $^1/_{30}$ and $^1/_{45}$ second. In some cases, Tric shutter speeds were set as high as $^1/_{125}$ second; however, Tric does not offer high-speed sync options, and there are occasions when the flash and shutter do not match.

Please! Anywhere But the Bathroom!

The bathroom seems to be one of the most common locations to take a selfie, and I have never understood why. A self-portrait should have no less thought and effort put into it than any other portrait. For the best results, it's wise to think about the location, the background, and the purpose of the portrait.

Selfies do not need to be boring. A creative, well-done self-portrait can inspire photographers to share their photograph with others. These photos,

after all, document a moment in our lives.

I am more likely to take a selfie for professional reasons than for fun. That's my style. My kids, on the other hand, take selfies on many occasions and in numerous locations. Because my selfies tend to be made for professional reasons, and because I am self-conscious, I pay attention to the details. I consider the lighting, angles, and composition.

I took three separate images of myself. The first two were made indoors, while the final image was made outside. I used a tripod to support the phone in each instance, and I concealed a remote shutter release in one hand. This allowed me more freedom to pose as I wanted to, without the awkward and unmistakable look of an extended arm.

The first two selfies (image 14.1 and 14.2) took some time and planning, as I used the iPhone's rear camera. This was a challenge, because I could not see how the image was framed. But I could shoot in RAW. The downside when working this way is that it can take a while to get an image you are happy with.

I used the iPhone's front camera for the outdoor photo (image 14.3). There

top. Image 14.1.
bottom. Image 14.2.

"It is a good idea to take front-camera photos in TIFF format if it is available."

are a few drawbacks to using the front camera. The first is that the image sensor is smaller (fewer megapixels), and the image quality is approximately half that of the phone's rear camera. The second is that the front camera will only take photos in JPEG or TIFF format.

It is a good idea to take front-camera photos in TIFF format if it is available, as it produces higher-quality images. However, remember that while a TIFF is uncompressed, it is still a processed image. You may notice some limitations in editing, which includes an observable reduction in image quality when compared to those taken in RAW format.

above. Image 14.3.

15. Accessories

It seems there are new accessories available for the iPhone every day. However, it is important to note that not every manufacturer makes accessories that can be used with all brands. For example, Tric only works with iPhones, whereas products like Moment and Profoto are more universal.

Is there a need to go out and purchase accessories? Absolutely not. They are certainly not required to take a nice photo. In fact, you can do almost every-thing demonstrated in this book with your iPhone as a standalone tool. Adding the right accessory can, however, help you overcome some limitations.

Lenses

Lenses are some of my favorite accessories to play with. There are several manufacturers on the market that produce accessory lenses for your iPhone. Each one is different, and it will take some research on your part to decide

below. **Moment lenses.**

right. **Profoto C1 Plus.**

right. **Profoto C1 Plus.**

if one of these products is right for you. I use Moment lenses. They are one of the more expensive after-market lens manufacturers, but they appear to have the best image quality when compared to other brands.

In any event, these lenses are placed in front of the native camera lens, and most can be adapted to both front and rear-facing cameras. Each lens manufacturer has its unique method for attaching its lenses to your iPhone. For example, Moment requires you to purchase their iPhone case to attach their lenses, but cases are not available for all iPhone models. They offer a universal adapter that will help position a lens over the front or rear camera if a phone case is not available for your specific model. Lenses are also not specific to iPhone, and can be mounted on almost any smartphone.

Each manufacturer is different regarding the available focal length of their after-market lenses. Some common options for Moment lenses are: 58mm telephoto lens, 18mm wide-angle lens (below 24mm is considered an ultra-wide), 14mm fisheye lens, and 25mm macro lens (Moment markets the lens as a 10x macro).

External Lighting

Profoto. There are a few manufacturers that make off-camera lighting options. However, these can be pricey, and depending on the manufacturer, there may be a slight learning curve. Profoto makes the C1 and C1 Plus, which I used for some of my shoots. The unit is commonly hand held but can also be

"The light can produce harsh shadows, and it takes experimenting to get the angle and intensity right."

Tric. The Tric Xeon flash trigger is a less expensive alternative that acts as a hot shoe to connect a speedlight, and some studio strobes, to your iPhone. The product is not currently available for Android phones. There are some limitations with the device related to sync speeds. The iPhone XS and newer models are limited to shutter sync speeds of approximately $1/35$ second (though I found that I could use shutter speeds as fast as $1/60$ second with no issues). Shutter speeds of $1/125$ second and faster do not correctly sync with the flash. This creates a challenge when using a speedlight outdoors, as working with slower shutter speeds can overexpose your images.

above. **Tric trigger.**

placed on a light stand. The light can produce harsh shadows, and it takes experimenting to get the angle and intensity right.

Profoto also makes off-camera studio strobes, including the B10 and B10 Plus. These strobes can sync to your Apple or Android device, and they use the same camera app that operates the C1. The strobes can also be paired with a conventional DSLR. Unfortunately, the price is more than $1,000 U.S.

16. Develop Your Style

Develop your style. Define your style. Work on your style. Whether you are a professional or an amateur, there will come a time when you will identify with a particular style. Amateurs and hobbyists may be slow to realize this but, as time progresses, will start to notice similarities in your images. It took me years to figure out what my style was. I didn't even know I had a style until a friend told me that they can always recognize one of my photos.

Who Are You?

Your style is important. Why? Photography is an expression of who we are. We capture that which portrays how we see the world around us. It still fascinates me when I ask someone why they took a photo, and their response is, "I don't know." They *do* know, and they knew at the time that the shutter button was pressed. Something stood out to them that held significance at that moment.

Your style is defined in that quick snapshot of the kids, your significant other, friends, or that flower on the side of the road. It is evident in how you frame your subjects, how they are illuminated, how you edit, and even what subjects you commonly take photos of. I must admit, I didn't get it at first, but I found that it is essential to understand this, because it will help you to become a better photographer.

What's my style? Look back at the images I have shared and see if you can identify what it is. My style varies based on whether I am photographing people, landscapes, abstract objects, abandoned buildings, or other subjects. It depends on my mood. But the underlying essence that defines my photography is there. You can see it in my lighting preferences, my editing, the time of day I shoot, and each photo's composition.

"Ignore criticism when it was not sought, and accept constructive critiques from those whose opinions you value."

The important takeaway is that your style is yours, and yours alone. Photography is an art, and art is subjective. Ignore criticism when it was not sought, and accept constructive critiques from those whose opinions you value. Practice. Never stop learning. Try new techniques, and ask yourself, "How could I have done this differently?" Don't be afraid to try new things. This is the digital age, and memory is cheap. You will find that you may take many photos initially, but you tend to become more precise and less trigger happy as you craft your art.

Print It!

I am an advocate for printing photos. Printing your work is a rewarding experience and one of the greatest motivational factors when it comes to affirming your talents. When you first see one of your pieces in a frame, on a metal print, or on any other type of media, the feeling is indescribable.

Your photographs belong on a table, a wall, a desk, or wherever. If we are taking more photos than ever before, then why are we showing them off less and less? Images spend more time on hard drives and smartphones than on display. If our photographs are a representation of who we are as people, then we need not hide them. Digital formats are not archival. They change. Manufacturers often develop proprietary formats, which may not be universal. A day will come when you will no longer be able to access those digital files, or you will have to pay to have them converted. A print, on the other hand, is archival.

Learn to Change

My style changes consistently, but the focus of my photography has not. A camera is a tool to bring to life your unique vision and to document a reality that can be shared with everyone. However, the real creativity comes from within you. Play with your camera settings, angles, changes in light, and editing techniques. You can always take more photos, and generally, undo what you have done on the computer. If you don't like the way something looks in your photos, change it.

I will leave you with a few of my favorite quotes. As a photographer, I often reflect on them. Hopefully, you will find inspiration in them as well.

"Real creativity comes from within you. Play with your camera settings, angles, changes in light, and editing techniques."